OLIVER & BOYD

PRIMARY ART

Knowledge and understanding in art

Robert Clement
and Shirley Page

Oliver & Boyd
An imprint of Longman Group UK Ltd
Longman House, Burnt Mill, Harlow, Essex CM20 2JE, England
and associated companies throughout the world.

© Oliver & Boyd 1992

First published 1992
ISBN 0 050 050869
Set in 11/14 Gill Sans Light
Printed in Hong Kong
SK/01

Designed by Roger Walton Studio

The publisher's policy is to use paper manufactured from sustainable
forests.

Acknowledgements

To Alison Kelly, Head Teacher, Stuart Road Primary School, Plymouth for permission to use worksheets she has designed for use in her school; Reg Stokes, Head Teacher, Elburton Primary School, Plymstock for permission to use his photographs of children visiting an exhibition and working with an artist (figures 5.8 and 5.9); and the Head Teachers of the following schools for permission to include in this publication examples of work by children in their schools.

Barton Infants School, Torquay
Beaford Primary School
Bridgetown C of E Primary School, Totnes
Brixington Junior School, Exmouth
Cowick First School, Exeter
Dartington C of E Primary School
Decoy Primary School, Newton Abbot
Exwick Middle School, Exeter
Manor Primary School, Ivybridge
Newport Primary School, Barnstaple
Oldway Primary School, Paignton
St John's RC First School, Tiverton

St Joseph's RC Primary School, Newton Abbot
St Michael's C of E Primary School, Kingsteignton
St Nicholas RC Combined School, Exeter
Southway Infants School, Plymouth
Stoke Hill Middle School, Exeter
Stuart Road Primary School, Plymouth
Thornbury Primary School, Plymouth
Topsham Middle School, Exeter
Widey Court Primary School, Plymouth
Woodfield Junior School, Plymouth
Woodford Primary School, Plympton

We are grateful to The Society of Authors on behalf of Nicolete Gray and the Laurence Binyon Estate for permission to reproduce an extract from the poem 'The Burning of Leaves' by Laurence Binyon.

We are also grateful to the following for permission to reproduce photographs: Aberdeen Art Gallery & Museum, page 25; Birmingham City Museum & Art Gallery, page 86 *right* (photo: Visual Art Library, London); British Library, London, page 19 *left*, Trustees of the British Museum, London, pages 18, 19 *above right*, 27, 41 *above*, 83; © DACS 1992/Bentili Werd Verlag, pages 48 *above left*, 48 *above right*; © DACS 1992/The Tate Gallery, London, 68 *right*, W R Hornby-Speer/The Tate Gallery, London, page 59 *above left*, Glasgow Art Gallery & Museum, page 13 *above right*, The Solomon R Guggenheim Foundation, New York, Justin K Thannhauser Collection, 1978. Photo: Robert E Mates. Copyright The Solomon R Guggenheim Foundation, New York, FN 78. 2514 T22, page 48 *below left*; David Hockney/The Tate Gallery, London, pages 26 *above*, 56 *above* (photo: E T Archive, London); Manchester City Art Gallery/Bridgeman Art Library, pages 40 *right* (detail), 60 *right*, © Succession H Matisse/DACS 1992/The Pushkin Museum, Moscow/Bridgeman Art Library, London, page 16 *left*, Henry Moore Foundation, page 48 *below right*, Musées des Beaux-Arts, Brussels, pages 12 *below*, 31 *above* (detail), 40 *left* (detail), 82 left; Collection, The Museum of Modern Art, New York. Given anonymously, pages 15 *below left*, 85 *above*; The National Gallery, London/Bridgeman Art Library, London, page 30 (detail); The National Gallery, London/E T Archive, pages 62 *centre* (detail) 67; Saatchi Collection, London, pages 12 *centre*, 40 *centre*; City of Salford Art Gallery, pages 26 *centre*, 105, 106; Alfred Stieglitz Collection, Gift of Georgia O'Keeffe, 1969.835. Photograph © 1991. The Art Institute of Chicago. All rights reserved, page 68 *left*; The Tate Gallery, London, pages 22, 41 *below*, Trinity College, Dublin, page 19 *below right*.

Contents

Introduction

This series of books and the supporting Resources Pack that make up this 'Primary Art' project have been put together to give teachers in primary schools support with the introduction of the National Curriculum in Art. Although each of these books is free standing and will provide help for teaching particular aspects of Art and Design, they have been designed to be complementary and, together, will give comprehensive guidance for teaching Art in the National Curriculum.

In *Art for ages 5–14*, published by the Department of Education and Science in August 1991, the Art Working Group identified a number of factors that are common to those primary schools where there is consistently good practice in the teaching of Art and Design.

'The head and teachers share aims and objectives, often expressed in a clearly stated policy document.'

'The continuity provided by individual teachers planning within that agreed policy is an important factor.'

'The staff give clear guidance, where appropriate, having analysed the steps that pupils need to take to gain a skill or understand a concept.'

There is balance between 'the activity of making art, craft and design with opportunities for pupils to reflect upon and discuss their own work and the work of others'.

Children's drawing abilities are developed 'to the point where they are at ease using drawing as a tool; for example, to aid thinking'.

Children develop 'confidence, value and pleasure in making art, craft and design'.

The overall quantity of work in Art and Design in any primary school is determined by these kinds of factors and by the way that teachers within that school work together to put in place an art curriculum that matches the coherence that the National Curriculum has brought to other subjects. We hope that this series of books will help teachers to meet the challenge of the National Curriculum in Art and to put in place

in their own schools the consistency and quality of practice that will best serve the abilities and needs of their pupils.

In this work we have drawn extensively upon examples of good practice in the teaching of Art and Design from a wide variety of schools, ranging from small village schools to large schools serving urban communities. We wish to acknowledge the important contribution that the teachers in these schools had made to our work and thinking in art education. The quality of children's work in Art and Design and its relevance and meaning to them rests upon the enthusiasm and commitment that teachers like these bring daily to their work in schools.

Bob Clement and Shirley Page

PRINCIPLES AND PRACTICE

This book describes those general principles that determine the teaching of Art and Design: its aims and objectives, Attainment Targets, the development of image making, structure and sequence, placing work in context, cross-curricular issues, assessment and appraisal.

KNOWLEDGE AND UNDERSTANDING IN ART

This book examines the place of critical and contextual studies in Art and Design: how to use works of Art and Design to support children in their making of images and artefacts, how the study of works of art can generate reflection and appraisal, how children can be helped to understand the relationship between their own work and that of other artists working in different times and cultures.

INVESTIGATING AND MAKING IN ART

Part I 'Investigating' describes how children can develop and use a range of drawing skills to describe and investigate their experiences and how these can be used in association with a wide range of resources to develop their ideas and concepts.

Part 2 'Making' provides detailed guidance for the organisation and teaching of a wide range of art and design disciplines, including painting and drawing; two- and three-dimensional design. It also provides a structure for the development of children's visual language and allows them to reflect upon their making.

The Programmes of Study for understanding in Art

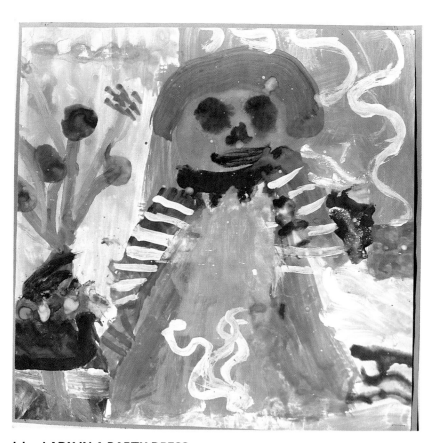

1.1 LADY IN A PARTY DRESS
Year 1
Tempera
Painting made in response to
looking at and talking about Henri
Matisse's 'The Purple Robe'.

INTRODUCTION

The introduction of the National Curriculum in Art brings with it an emphasis upon using and learning about the work of other artists and designers that will be new to many teachers in primary schools. The reasons for this are set out in the Final Report from the National Curriculum Art Working Group, *Art for ages 5 to 14*:

> 'We believe it is important for pupils to gain a developing awareness of the work of others. The history of art and the diverse ways in which art occurs in other cultures and contexts need to be taught in their own right. Until pupils have gained sufficient experience to make informed judgements they must proceed intuitively, by simple likes and dislikes rather than by knowledge and reason. As pupils get older, this process should be complemented by the study of art history and social, economic, religious and cultural contexts. Such study requires knowledge, skills and understanding. Pupils need the ability to 'engage' with an artefact, i.e. be willing to devote time and energy to responding and relating to it.'

Many teachers in primary schools have recognised the importance of using 'critical studies', both to inform the children's own work and to help them better understand the context within which art is made. In many other schools, however, children's making of art is locked too much within the classroom and with too little attempt to help them understand that important connection between their own work and that of other artists, craftworkers and designers.

Children's making in Art is clearly enriched through their studying the work of other artists and designers in much the same way that their work in language is supported through reading the work of many storytellers and poets. Through reading widely they can come to an understanding of the possibilities of language: through familiarity with the work of other artists they can begin to understand the possibilities of image making. It is obvious, for example, that children learn a great deal about making a painting and how to use colour by looking at the work of other painters. This is much the same as the way they learn about making a poem by considering the way that different poets have written in response to familiar themes.

In providing children with access to a wide range of work by artists and designers working in different times and cultures, you can help them to understand the different contexts within which art is made and for what rich variety of reasons and purpose.

The National Curriculum in Art recommends that children's under-

standing of art should be encouraged and developed through three different strands or components of work:

A Identifying different kinds of work in art and design and the purposes for which they are made.

B Understanding how works of art and design are influenced by the different times and cultures within which they are made.

C Making practical and imaginative connections between their own work and that of other artists and designers.

In classroom practice this will lead to the following kinds of activities in **Key Stage 1** and **Key Stage 2**

Key Stage 1

By the end of key stage 1, pupils should be able to:	Pupils should:
A recognise different kinds of art.	i identify examples of art in school and the environment. ii identify different kinds of art, present and past.
B identify some of the ways in which art has changed, distinguishing between work in the past and present	iii look at and talk about examples of work of well-known artists from a variety of periods and cultures.
C begin to make connections between their own work and that of other artists.	iv represent in their own work their understanding of the theme or mood of a work of art.

Key Stage 2

By the end of key stage 2, pupils should be able to:	Pupils should:
A identify different kinds of art and their purposes.	i compare the different purposes of familiar visual forms and discuss their findings with their teachers and peers. ii understand and use subject-specific terms such as landscape, still-life, mural.
B begin to identify the characteristics of art in a variety of genres from different periods, cultures and traditions, showing some knowledge of the related historical background.	iii look at and discuss art from early, Renaissance and later periods in order to start to understand the way in which art has developed and the contribution of influential artists or groups of artists to that development. iv identify and compare some of the methods and materials that artists use.
C make imaginative use in their own work of a developing knowledge of the work of other artists.	v experiment with some of the methods and approaches used by other artists, and use these imaginatively to inform their own work.

The activities within these three strands of understanding in art will overlap and complement each other. They will have strong cross-curricular links particularly with that work in Technology and History that is already established within the National Curriculum in primary schools.

MAKING CONNECTIONS

The importance of helping children to make connections between their own work and that of others and using these connections to inform and enrich their work has already been discussed in *Principles and Practice*.

You can help children to begin to make these connections from their first year in school by linking the subject of their own drawings and paintings to work by other artists. It is easy to do this because so many artists have made work based upon the same kind of subject matter and experiences that you will want the children to respond to. There are many themes in Art and Design that have been common currency to artists working in different times and cultures: the portrait and self-portrait, mother and child, family groups, interiors and landscapes etc.

In encouraging children to make these connections between the images they make and those made by other artists you will be helping them to recognise that Art and Design is a universal activity that is important to all communties and cultures and not just something you do in school. By carefully selecting a range of work by different artists you can also help them to begin to recognise that artists work in different kinds of ways, use different materials and techniques and have different ways of responding to and interpreting familiar experiences and events.

In **Key Stage I** there are many natural opportortunities for linking children's work to that of other artists in their day to day making of images. When they make their first portraits of a friend or their mother or favourite aunt, you can usefully link this activity to looking at portraits made by other painters. When they make their drawings and paintings of the first spring flowers, this will lead easily into looking at the way that other artists have painted flowers and discussion about the colours and shapes they have used.

Figures 1.1 and 1.2 are paintings by children in Year 1 of a lady in a party dress which they made after painting themselves in their own special outfits and then compared these with Matisse's painting 'The Purple Robe'. Figures 1.3 to 1.5 are of drawings and paintings by children in Year 1 which were made as part of a class theme exploring 'The Harvest'. They looked at works by other artists on the harvest theme and used these directly to support their own work. Their main source of inspiration was Van Gogh's 'Wheatfield with Sheaves in Arles'.

In these early years, children will be intrigued with other artists' work both for its storytelling content and increasingly by the way the work is made. They will enjoy work that is full of incident, such as Leon Kossoff's 'Children's Swimming Pool' (figure 1.6) and paintings by Bruegel (figure 1.7) and Lowry (see Resources Pack no. 9 for an example), in which they will find familiar events and activities to talk and write about and to use as the stimulus for their own storytelling through drawing (figures 1.8 to 1.10).

They will also enjoy the challenge of unfamiliar work and of trying to 'puzzle out' what a more symbolic or abstract painting might be about. Because children in the early years use symbol systems freely in their

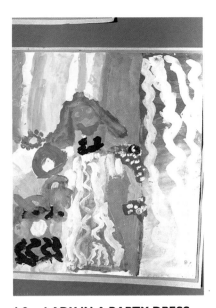

1.2 LADY IN A PARTY DRESS
Year 1
Tempera
Painting made in response to looking at and talking about Henri Matisse's 'The Purple Robe'.

1.3 THE HARVEST – CLASSROOM DISPLAY
Year 1

1.5 THE HARVEST
Year 1
Tempera

1.4 THE HARVEST
Year 1
Pencil

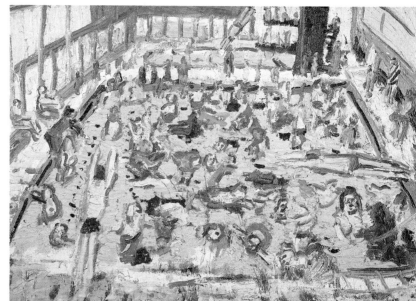

1.6 'CHILDREN'S SWIMMING POOL, 11 O'CLOCK SATURDAY MORNING, AUGUST 1969'
Painting by Leon Kossof
(Saatchi Collection, London)
*Resources Pack no. 2

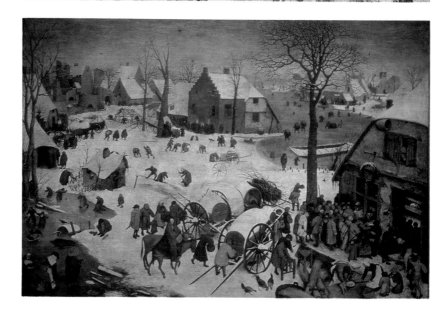

1.7 'THE CENSUS IN BETHLEHEM'
Painting by Pieter Bruegel
(Musées des Beaux-Arts, Brussels)
*Resources Pack no. 6

1.8 PEOPLE IN THE STREET
Year 1
Crayon
Drawing made in response to
observation of work by L S Lowry.

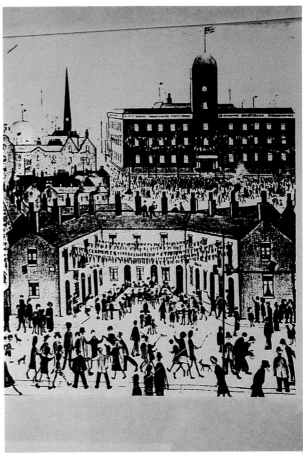

1.9 'VE Day 1945'
Painting by L S Lowry
(Glasgow Art Gallery and Museum)
*Resources Pack no. 9

1.10 VE Day 1945
Year 4
Microliner

own drawing and painting they are often more open-minded and curious about such work than older children who tend to be much more concerned with the 'rightness' of appearance (figures 1.11 to 1.15).

As children become more confident in their use of materials and resources, they will increasingly seek for information about the various ways that other artists and designers make their work and how they can use such information in support of their own making. Children can learn a great deal about how to make a drawing or painting by examining the work of others: by looking at the way that they use colour and pigment in different ways; by studying how they may paint trees or clouds; by comparing the different kinds of drawing systems that artists use. This will begin, as in the examples already illustrated in this chapter, through simple pastiche, where children will copy or 'borrow' directly from the work of others. Where the work is chosen carefully and where children are encouraged to work directly through different kinds of artists, such borrowing will help them to explore different kinds of artists' systems and different ways of representing their experience of the world.

In figures 1.16 to 1.18 it is evident that children in Year 5 have gained confidence in their use of colour and understanding of the way line may be used in a drawing by making direct studies from works by Matisse and Dürer. Figures 1.19 and 1.20 show how children in Year 6 were encouraged to study some of Rodin's drawings of figures to see how they might use and apply what they learn to their own figure drawings.

**1.11 STUDY AFTER PAINTINGS
BY PAUL KLEE**
Year 2
Ink and watercolour

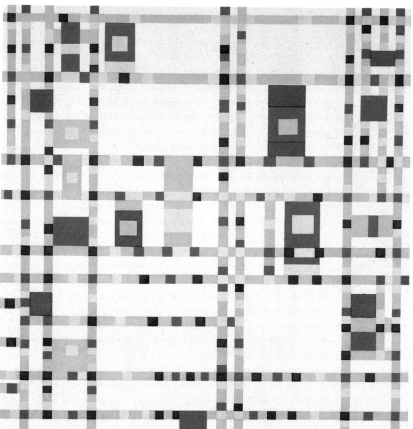

1.12 STUDY AFTER PAINTINGS BY PAUL KLEE
Year 2
Ink and watercolour

1.14 STUDY FROM THE PAINTING 'BROADWAY BOOGIE-WOOGIE'
Year 3
Tempera

1.13 'BROADWAY BOOGIE-WOOGIE'
Painting by Piet Mondrian
(Museum of Modern Art, New York)
*Resources Pack no. 24

1.15 STUDY FROM THE PAINTING 'BROADWAY BOOGIE-WOOGIE'
Year 3
Tempera

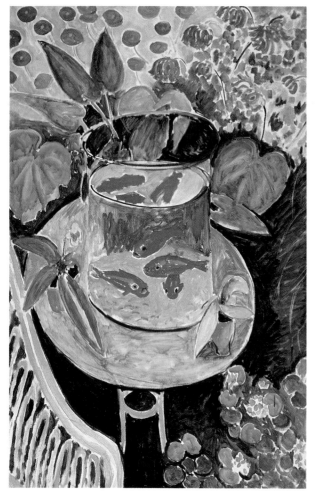

1.16 THE GOLDFISH BOWL
Painting by Henri Matisse
(The Pushkin Museum, Moscow)
*Resources Pack no. 7

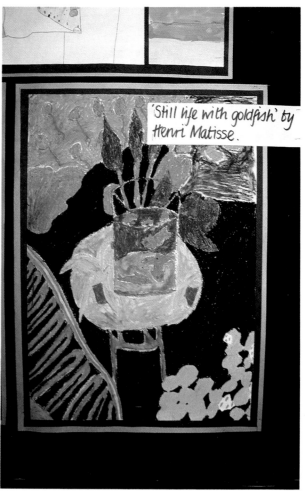

1.17 STUDY FROM THE HENRI MATISSE PAINTING
Year 5
Oil pastel

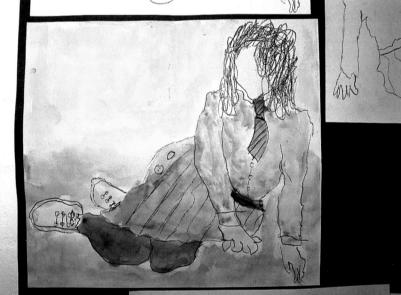

1.18 STUDY FROM A DRAWING OF A HARE BY ALBRECHT DÜRER
Year 5
Biro

1.19 FIGURE STUDIES AFTER RODIN
Year 7
Conte and watercolour
Made from children posing in the classroom after the study of figure drawings by Auguste Rodin.

We did our line drawings using black Conte sticks, took a photocopy and added a watercolour wash. Rodin used this effect in his drawings.

We did quick line drawings to capture the body form.

1.20 FIGURE STUDIES AFTER RODIN
Year 7
Conte and watercolour
Made from children posing in the classroom after the study of figure drawings by Auguste Rodin.

Where this kind of systematic use of reference to the work of other artists is built into the children's programmes of work in Art and Design they will become increasingly confident in their handling of a range of systems and methods in their own work. This will develop a real knowledge and understanding of the possibilities of image making. They will go beyond simply making connections between their own work and that of others and will begin to use the work of other artists, craft-workers and designers imaginatively to inform their own making of images and artefacts. Some of these methods are discussed further and in more detail in chapter 3.

ART AND DESIGN IN A WIDER CONTEXT

Through being encouraged to make connections between their own work and that of others, children will come to learn about the way that other artists work, what processes and systems they use, how they interpret and use visual experience and how they express ideas and feelings. Their understanding of the different purposes for which Art is made and in what different context artists have worked will depend upon the range of work they experience. In order to have a good understanding of Art and Design in a wide context, they need to have access to and experience of the work of artists, craftworkers and designers working in many different times and cultures.

Because we have easy access through publications and reproductions to the work of popular European artists working between the 16th and 20th centuries, it is all too convenient for the children's diet of other artists' work to be restricted to such familiar figures as Bruegel, Van Gogh, Matisse, Rousseau, Lowry and Hockney. Important though these artists are (they are all represented within the Resources Pack that accompanies this publication), their work represents only a narrow segment of artistic achievement. They are all men working within a European tradition that stretches back 400 years to the Renaissance within a history of Art and Design that spans thousands of years and many non-European cultures and communities.

Artists working in different times and cultures

It is important to try to give children access to the work of artists and designers working in other cultures and times. In this way they will come to value artistic traditions other than those of Europe and to recognise how works of art are made for different and important purposes in cultures other than our own. There is no doubt that in teaching Art we can contribute significantly to children's recognition and celebration of the differences between European and non-European cultures and to developing their respect for the work of the different ethnic groups in our multi-cultural society (see figures 1.21 to 1.24).

Children enjoy the challenge of discussing and deciphering work from different times and cultures and will be interested in both the purpose for which these works were made and the range of processes and systems used by artists working in other cultures. The cave painters at Lascaux, the medieval makers of illuminated books, the African carvers and the Persian miniaturists, all used deceptively simple technologies to make images and artefacts of tremendous power and sophistication which will challenge our assumptions about the superiority of twentieth century technology.

This new emphasis on using historical evidence to support teaching the National Curriculum in History opens up many possibilities for more than useful cross-reference between the teaching of Art and History in **Key Stage 1** and **Key Stage 2**. This is discussed in chapter 5 of *Principles and Practice*. The new History curriculum requires that children should

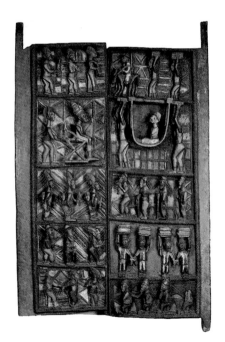

1.22 'CARVED WOODEN GATES'
Yoruba
(British Museum, London)
*Resources Pack no. 8

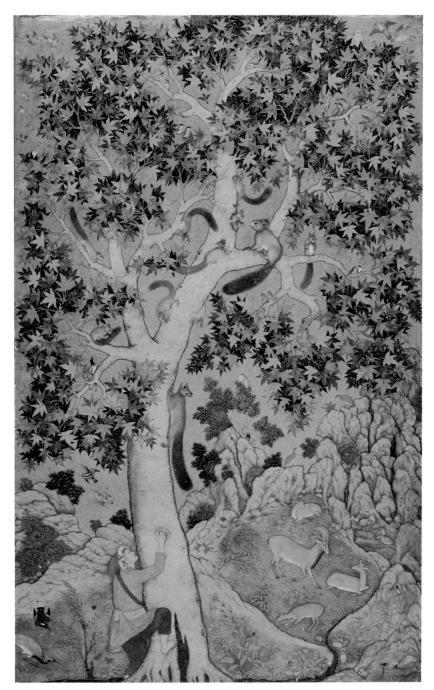

1.21 'TWELVE SQUIRRELS IN A CHENNAR TREE'
Abu'l Hasan, circa 1630
(British Museum, London)
*Resources Pack no. 5

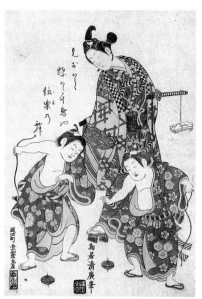

1.23 'THE SPINNING TOP'
Print by Torii Kiyohiro, 1751–57
(British Museum, London)
*Resources Pack no. 14

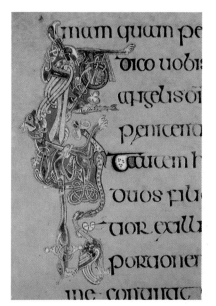

1.24 'THE BOOK OF KELLS'
Illuminated manuscript
(Trinity College, Dublin)
*Resources Pack no. 17

study the history of people living in different times and cultures and should use the images, artefacts and environments made by artists, craft-workers and designers working in these times as important evidence of the way that these people lived.

There will be many opportunities for you to help the children to make connections between the familiar images and artefacts we encounter

1.25 MYTHICAL BEAST
Year 5
Oil pastels
Drawing made after the study of
ornamented beasts in The Book of
Kells.

1.26 MYTHICAL BEAST
Year 5
Oil pastels
Drawing made after the study of
ornamented beasts in The Book of
Kells.

every day and those that have been made in previous times and in other places. In Years 1 and 2 it is commonplace to begin to give children some sense of history and of the passing of time through making comparisons between the clothes we wear and the things we use today compared with those worn and used by parents and grandparents. We can reinforce this through collecting and investigating evidence of past times. Such familiar artefacts as shoes, hats, toys and teapots from different times and places and made for different occasions will lend themselves to good discussion and investigation about how things are designed and made and why their appearances change in response to different needs. Much of this kind of work will also link in with Technology and to the investigation that needs to take place to identify the needs and opportunities for designing and making.

Wherever the school, there will be evidence of the way that the local community has developed over the years through the study of its houses, public buildings, street furniture and monuments. A 'timeline' of the community's housing can be constructed by collecting photographs of houses from local estate agents: most local newspapers have an archive of photographs which trace the changing appearance of the community.

There is also a lot of evidence of the way that graphic designers, illustrators and photographers influence the appearance of our environment. You can investigate and compare such familiar things as: book illustrations, shop lettering, postage stamps, posters and package design, television commercials and animated cartoons.

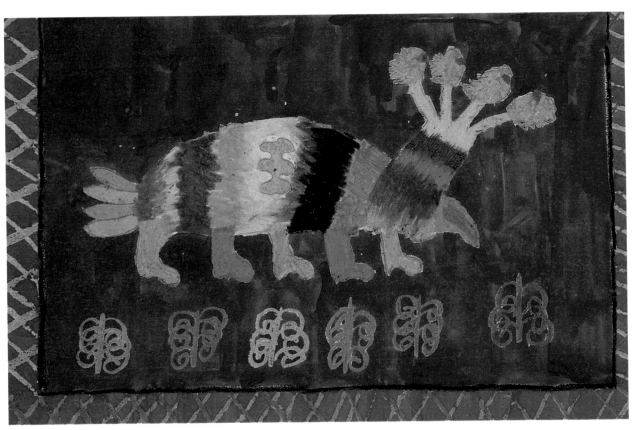

In providing children with access to a wide range of forms and in helping them to see that artists and designers have had and continue to have a significant impact upon our everyday lives through the work they do, you will be reinforcing their understanding of Art and Design in its widest context. The use of the work of artists and designers as historical evidence is discussed further and in greater detail in chapter 4.

A comprehensive list of sources and resources available in the locality for investigation by children is provided in chapter 6 of *Investigating and Making in Art*, Part 1.

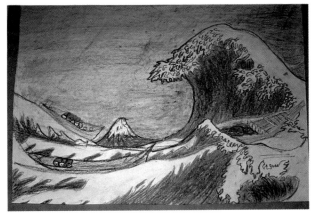

1.27 STUDY FROM 'THE WAVE' BY KATSUSHIKA HOKUSAI
Year 4
Chalk and pastels

1.28 STUDY AFTER ABORIGINAL DRAWINGS
Year 3
Crayon and pastel

1.29 STUDY AFTER ABORIGINAL DRAWINGS
Year 3
Crayon and pastel

1.30 STUDY AFTER CHINESE PAINTINGS
Year 2
Ink and watercolour

2 Strategies for using works of Art and Design

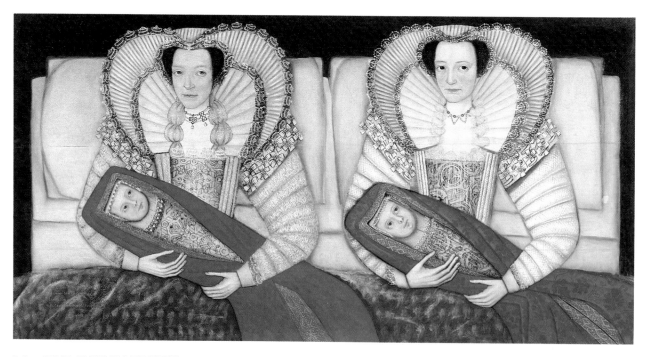

2.1 'THE CHOLMONDELEY SISTERS'
British School, circa 1600–10
(The Tate Gallery, London)
*Resources Pack no. 3

STRATEGIES

There are many different ways in which you can use works of Art and Design to encourage children to give them the time and attention that is needed for them to begin to make sense of the work. Helping children to focus upon a work, to begin to 'read' it, and to understand some of its complexities requires careful planning and the use of different teaching strategies to support the variety of ways that children can respond to a work of art.

Perhaps the first and most important task is to find ways to help children give proper time and attention to the work. Because we are bombarded with visual images in our daily lives through television, film, advertising and the press, it is all too easy for our reading of images to become very undifferentiated. The picture on the wall, in the book, on the advertising hoarding, on the television screen and in the comic – and in their profusion – all tend to encourage an instant 'like or dislike' response.

When children – or adults – make a visit to an exhibition or art gallery, they will often shuttle from picture to picture at great speed, seeking for and pausing only for the picture that forces itself upon their attention.

You may find that when working with children in music there are similar problems in trying to find ways to help them listen to music carefully and constructively when they are subjected to so much undifferentiated musical sound at home and in the community. There are many familiar teaching methods and ploys that you can use to focus children's attention, to generate discussion, enquiry and research that may be used in a similar way in your work with children in Art and Design. Many of these methods are demonstrated and used in the Resources Pack which accompanies this publication. Each of the works illustrated is supported by suggestions for discussion, research and making activities that the work may generate.

QUESTIONING AND TALK AS FOCUS

As in all your work, the various ways in which you can generate children's response through good talk, discussion and questioning will have a significant bearing upon the way that they focus upon and receive a work of art, craft or design. Younger children tend to be more open and less conservative in their response to works of art. They receive them as just another picture they would like to talk about; whereas children in **Key Stage 2** may view them more specifically (and suspiciously) as works of art that need to be viewed in a particular light.

In **Key Stage 1** you are more likely to be able to generate good and open discussion with children on the basis of interest and curiosity about the work. In **Key Stage 2** you may need to use more subtle ploys and specific questioning to encourage the children to give time and attention to the work.

However the works are viewed, they need to be accessible for individual or group discussion. If the emphasis is to be upon individual response to different works, then there should be enough reproductions or photographs for the children to share them one between two. If you wish to generate a group or class discussion focused upon one work, then you will need a poster-sized reproduction for the class to share with you. Even more ideally, you need a poster of the work for class viewing supported by postcards of the same work to be shared individually or in pairs.

Where you have the facilities, it is useful to occasionally show children works of art in the form of colour slide projections either through a projector or with a daylight viewing screen. This is a particularly useful way to give children a true picture of the work's colour values and its scale. Some large paintings, like Uccello's 'The Battle of San Romano' (Resources Pack no. 21) and Hockney's 'Mr and Mrs Clark and Percy' (Resources Pack no. 12) can then be shown to the class in their real scale. Their effect will be more dramatic than the conventional postcard.

Some works will easily generate immediate response and discussion, especially those with a strong storytelling element – like 'Tropical Storm with a Tiger' by Henri Rousseau (Resources Pack no. 1) or those, like Millais's 'Autumn Leaves' (no. 11) which relate to children's own experiences. Other works need more subtle presentation to place them in context for children or to help them begin to see where they might get into the picture.

Although some group discussion about paintings can be spontaneous and you will be able to build upon the children's immediate response, you will sometimes need to prepare the class for more open discussion. This can be best achieved by allowing the children some time to talk about and investigate the work in smaller, table-based groups. They can share their initial responses to the work with their friends before embarking upon class discussion. You will be able to generate some good class discussion through the preparation of a carefully structured sequence of questions and support group discussion through the use of questionnaires and worksheets.

Questioning about works of art can be structured and used in different ways depending upon the work itself and the purpose or focus for the children's observation of the work. For example, if the main purpose of the lesson is simply to encourage children to investigate the work carefully and to observe its detail and subtleties, then the questioning might be as follows (see figure 2.1):

● If you know any twins, are they 'identical' or 'different'?
● Are there any children in the class with the same birthday?
● Do the babies in the picture look like real children?
● Why do you think they were painted like this?
● Look for differences between the two ladies, first of all in their faces.

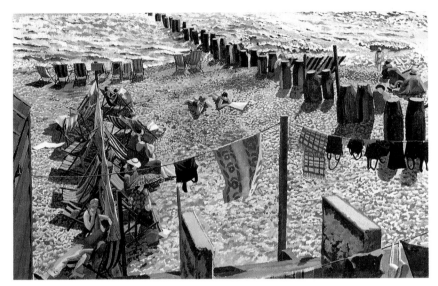

2.2 'SOUTHWOLD'
Stanley Spencer, 1937
(Aberdeen Art Gallery and
Museum)
*Resources Pack no. 16

● Look at the colour and shape of their eyes and those of their babies. How are they different to each other?
● Are the patterns around the edge of their ruffs the same?
● What do the shapes of the ruffs remind you of?

Questioning may be used more specfically to direct the children towards observing the way that the work was made, how the artists used colours or obtained certain kinds of effects. For example (see figure 2.2):

● What time of day do you think it is in this painting?
● What clues can you find to help you?
● What direction is the light coming from?
● Is the light bright and intense or soft and gentle?
● Does it feel hot or cool in this painting?
● What colours has the artist used to paint the water and waves?
● How does the artist make you see into the distance?

Or questioning may be used, pehaps more openly, to encourage children to speculate about a work. For example (see figure 2.3):

● What kind of people are Ossie and Celia Clark?
● What can you tell about them from their clothes and possessions?
● Why do you think that they want to have their portraits painted?
● How do you and your family 'pose' for a special occasion?

Using questioning in this kind of way will encourage children to observe works or Art and Design more carefully. It will give them the time and consideration that is essential to their beginning to understand how and why they were made.

**2.3 'MR AND MRS CLARK AND
PERCY'**
David Hockney, 1970–71
(The Tate Gallery, London)
*Resources Pack no. 12

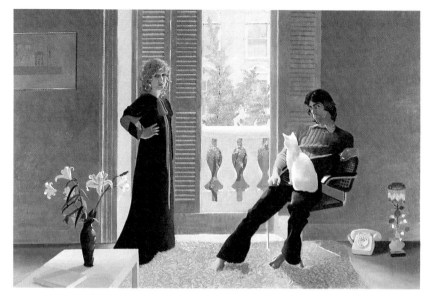

2.4 'THE CRIPPLES'
L S Lowry, 1949
(City of Salford Art Gallery)

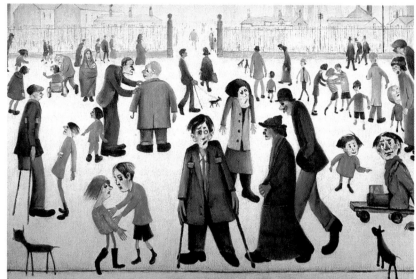

**2.5 STUDY FROM 'THE
CRIPPLES'**
Year 5
Micro liner
Using a magnifying glass to study
the detail within the reproduction
of a painting.

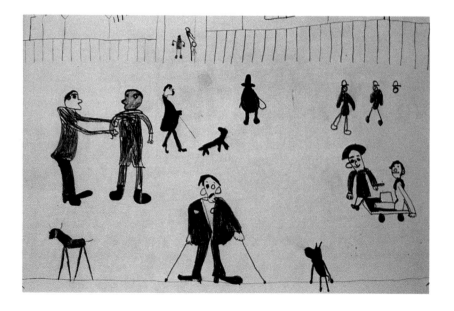

FOCUSING DEVICES AND PLOYS

There are a number of familiar devices and ploys that you can use to support children's exploration of works of art. These will help them to begin to make sense of what may well be detailed and complex images.

Magnifying glasses

When using a collection of small-scale or postcard reproductions of works of art you will need to have magnifying glasses available so that the children can properly see the detail and complexity of the artist's work. These are also useful when children are being asked to seek sections or passages within a work that they find particularly interesting or rewarding.

2.6 USING VIEWFINDERS
Studying the painting 'Landscape at Mont Majour' by Vincent Van Gogh (*Resources Pack no. 13) to identify how the artist takes the onlooker for a walk back into the landscape space.

Viewfinders

You will be familiar with the use of viewfinders as a support for children's work in drawing and painting, where they are asked to use them to select sections from a complex environment for study. Viewfinders can be used similarly in making studies from works of art and design, so that the children can focus in upon one part of a work for particular study. Or they can find, individually and in groups, different things of interest within the same work.

Viewfinders can be used in different shapes and sizes for different purposes. For example, young children might enjoy viewing a seascape through round viewfinders like sailors peering through telescopes. Older children might use narrow, vertical viewfinders to help them focus upon one section within a landscape painting and to see the way that a painter like Vincent Van Gogh might take the onlooker for a walk back into the landscape space (see figure 2.6).

Figures 2.7 and 2.8 are studies by children in Year 4 who have used round viewfinders to find and record interesting passages of shapes and colours within still-life paintings by Henri Matisse. Figures 2.9 to 2.11 are studies by children in Year 5 who worked in groups in making studies from the painting 'The Doctor' by Sir Luke Fildes and who identified 'key' passages within the story presented within this painting.

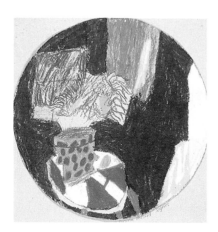

2.7 USING VIEWFINDERS
Year 4
Chalk and pastel

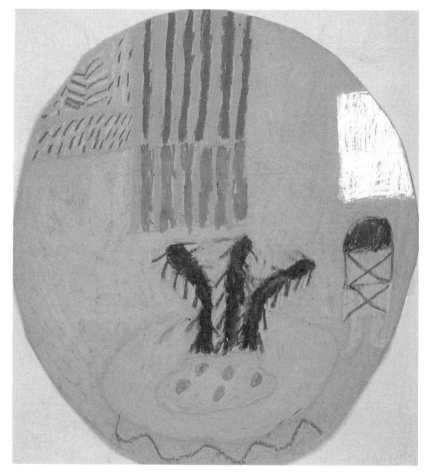

2.8 USING VIEWFINDERS
Year 4
Chalk and pastel

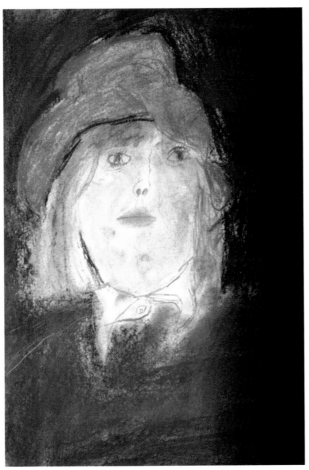

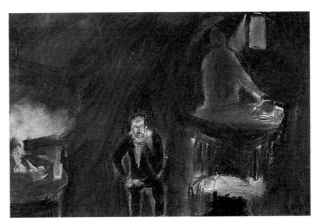

2.9 USING VIEWFINDERS
Year 6
Chalk and pastel

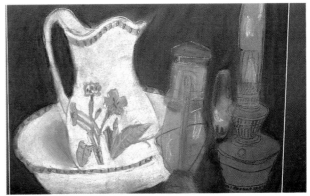

2.11 USING VIEWFINDERS
Year 6
Chalk and pastel

2.10 USING VIEWFINDERS
Year 6
Chalk and pastel

Story boards

Viewfinders may also be used to help children construct story boards from the study of narrative paintings. Many narrative paintings, such as Uccello's 'The Battle of San Romano' (Resources Pack no. 21), Bruegel's 'The Census in Bethlehem' (no. 6) and Lowry's 'VE Day 1945' (no. 9), present complex and detailed accounts of important historical events. Children can be encouraged to explore the detail of such paintings within the convention of the story board. This is where, as in comics or as in film and television accounts, the story is told as a series of images, often linked together through a commentary. A group of children can be asked to work together, using viewfinders to select key passages from a narrative painting and to use these to make a story board to explain the development of the story within the painting.

Children will also enjoy using the convention of the comic strip to explore the content of some paintings. Figure 2.14 is an amusing commentary by a ten-year-old about how David Hockney came to make his double portrait of Ossie and Celia Clark and their cat Percy (Resources Pack no. 12).

2.13 STORY BOARD

Using viewfinders to make a story board to describe the events within the painting 'The Rout of San Romano' by Paolo Uccello (*Resources Pack no. 21).

Drawing from oral description

You can use the ploy of asking children to make drawings from oral descriptions of paintings. This helps to build up both anticipation and curiosity about the work to be viewed and comparison between the artist's and the children's own 'version'.

You need to select work that seems appropriate to the level of drawing within the class and to describe it to the children carefully and in as much detail as possible. You will need first to give the children an outline description of the painting so that they understand what the work contains. Follow this up with a more detailed description that is presented at a pace that the children can match with their drawing. The children will need to be encouraged to ask questions about the content of the picture you are describing to them.

When the drawings are completed and the children are shown the

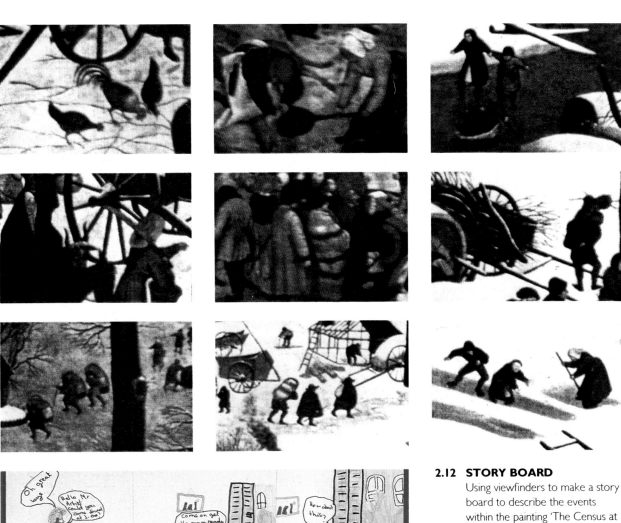

2.12 STORY BOARD
Using viewfinders to make a story board to describe the events within the painting 'The Census at Bethlehem' by Pieter Bruegel (*Resources/ources Pack no. 6).

2.14 CARTOON STRIP HOCKNEY
Year 5
Felt pen

work they have been drawing from description, they will be able to compare their version with that of the artist. This will lead inevitably to interesting discussion about the work. The choice of appropriate drawing materials and the scale on which you ask the children to draw are important contributory factors to the successful use of this ploy.

When you are working with younger children, most of them will be able to make this kind of drawing response to description of work quickly and unselfconsciously. With older children you may need to

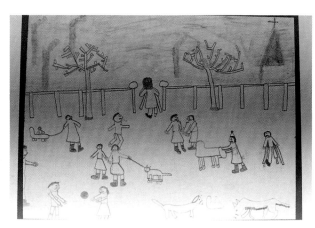

**2.15 'IN THE PARK' BY L S
LOWRY**
Year 4
Pencil

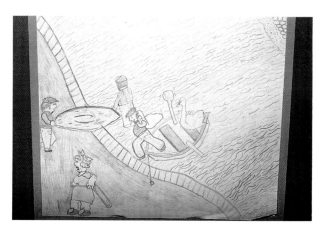

**2.16 'SWAN UPPING AT
COOKHAM' BY STANLEY
SPENCER**
Year 3
Pencil

**2.17 'LE VILLAGE' BY PAUL
GAUGUIN**
Year 5
Coloured pencils

**2.18 'LE CIRQUE FERNANDEAU'
BY TOULOUSE-LAUTREC**
Year 6
Chalk and pastel

match the oral description with a matching written description which they can consult and refer to as they make the work. In addition to describing the content of the work, you will need to provide clues about the way it is made. (Figures 2.15 to 2.18 are all of work made from oral description.)

Drawing from written description

Figures 2.19 and 2.20 are of drawings made by children in Year 6 in response to the teacher describing to them the painting 'The Artist's Son' made by Pablo Picasso. The children were also given the following text describing the work:

CAN YOU MAKE THIS PICTURE?
There is one person in this picture. A little boy is sitting sideways on a padded chair. The seat and the back of the chair are green – black. Around the seat are braids and tassels. Only the ends of

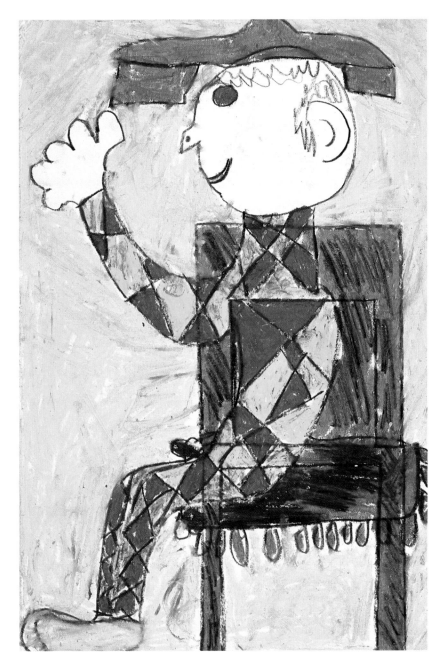

2.19 PAINTINGS MADE FROM WRITTEN DESCRIPTION
Year 6
Tempera

2.20 PAINTINGS MADE FROM WRITTEN DESCRIPTION
Year 6
Tempera

the legs are showing. The little boy is wearing a green black hat with square bits sticking out above his ears. He has brown hair that is cut in a fringe and there are little strands in front of his ears. He is wearing clothes a bit like a clown's. There are yellow and blue diamonds all over his suit. The diamond pattern is painted in black. He has a delicate ruffled collar around his neck. His hands are on his lap and he has ruffles around his wrists too. The shoes are drawn but not coloured. The background is pale ochre. Perhaps you could mix it with ochre and white and with streaks of light grey.

LIKES AND DISLIKES: THE BEGINNINGS OF CRITICISM

Until they have obtained experience in looking at and 'reading' works of art, children will proceed by simple likes and dislikes. This is where they will start towards developing the ability to appraise and criticise the work of other artists, craftworkers and designers.

The simplest way to engage children in some kind of appraisal is to give the group a selection of prints or postcards of works of art. Ask them to select one painting they particlarly like and to explain and extend upon their choice. It may be necessary to pursue this question of liking and disliking vigorously and through demanding of the children more than the standard and passive reasons for liking things; perhaps through requiring at least five different reasons why a work is liked.

It can be helpful to explain to the children that we enjoy paintings for different kinds of reasons. Sometimes we like them because of what they describe or the story they tell – because of the *content* of the painting; sometimes we like them because of the way that they are painted or made – we admire the *form* of the painting. Children can be asked to explain their likes and dislikes within these two categories of form and content or to consider such other categories as mood and atmosphere.

It also makes sense to place the selection of favourite work within a real context for them; for example, asking them to choose a work for themselves to hang in their own bedroom, or as a present for someone else.

Figure 2.21 shows the work of two girls made in response to Henri Matisse's paper collage 'The Snail'. They chose the work because it was one they would like to have in their homes. In the following they describe the work, why they like it and how they made their own versions:

> 'The Snail' is a picture by Matisse. I like the way all the colours blend together. The dark and light colours go very well together. There are blacks, maroons, blues and reds, greens and oranges. The lavender in the top left-hand corner is the only pastel shade. I think the picture is called 'The Snail' because it might have taken a long time to do. Matisse might have seen these colours in the snail's shell. It makes me think of a wonderful land with brightly coloured flowers and green hills with roaming stallions, with the sun shining all day long. Matisse loved colours and used to go abroad to Eastern countries and look at different colours and get ideas. I'd put this picture in my bedroom because I have a bright orange wallpaper.

> I think 'The Snail' is a lovely picture. I like the pattern and the deep colours and the bright colours. It is by an artist called Matisse. I like the orange background. It is like a jigsaw to do. I would put the picture in our lounge because the wallpaper is a creamy colour. When you look at the picture it doesn't look like

a snail. I think it's called 'The Snail' because it took Claire and me a long time to do to cut out and stick on all the pieces. We had to heave big wallpaper books around. We could hardly lift them because they were so heavy.

You can encourage children to be more specific about their reasons for liking or disliking different kinds of art work by asking them to discuss together and establish reasons why some works are preferred to others. Give a group a set of half a dozen postcards of different kinds of work and ask them to agree within the group an order of merit from most favoured to least favoured. They will also need to explain and list the qualities that made one of the paintings their 'Top of the Pics'.

Even closer examination of the reasons for liking or disliking work can be achieved when you give a group of children three or four prints of paintings which are similar in content but which are painted differently. You could, for example, select the three paintings of married couples from the Resources Pack – 'Mr and Mrs Andrews' (no. 19), 'The Last of England' (no. 15) and 'Mr and Mrs Clark and Percy' (no. 12) – and establish through discussion which work is most admired and why.

Such examination of and discussion about works of Art and Design should be extended to include that wide variety of images and artefacts available for study in schools, the home and the environment. You can ask the children to describe and comment upon some of the following:

● The best illustration in one of their story books.
● Their favourite ornament at home.
● The painting they most like in school.
● The local house they would most like to live in.
● The most exciting of the current television commercials.

2.21 'THE SNAIL'
Year 4
Collage and tempera

COMPARISON AND CRITICISM

There are many ways in which you can involve children in making comparisons between works of Art and Design and in so doing, encourage them to proceed beyond simply liking or disliking other artists' work.

You can begin by seeking opportunities for them to compare the images they have made with those made by other artists. There are many natural opportunities for this throughout the school year, when it will be appropriate to follow up the children's making of a drawing or painting by placing their work alongside that of other artists who have been working on similar themes. Many examples of this encouragement to children to 'make connections' between their own work and that of others were dicussed in chapter 1.

Sometimes, this comparing of their own work with that by other artists will lead to interesting discussion and comment about the work; at other times, it can lead on to further work (as in figures 2.22 and 2.23). After making their own drawings of the local postman or woman, the children compared their drawings with those of postman Joseph Roulin by Vincent Van Gogh. Then they made their own versions of Van Gogh's drawing. Using works of art in this way to inform their own work is dealt with in greater detail in chapter 3.

When children are using viewfinders to explore a complex work and to construct story boards to explain the work (see figures 2.12 and 2.13) they may well find interesting things to compare within one painting.

Many narrative paintings can lead children into making interesting comparisons between things that they do in their daily lives and the way that these are presented in works of Art and Design. Pieter Bruegel's painting of 'Children's Games' is a good example of a work that will encourage children to seek out the variety of activities that are taking place within the painting and to compare these with the games they play in their own community (figures 2.24 to 2.27).

Within the Resources Pack, the following works can be used to encourage children to study how artists have described familiar activities, to consider how effectively these have been presented and how they compare to their own experiences of these events:

'Children's Swimming Pool, 11 o'clock Saturday morning, August 1969'
 by Leon Kossoff (no. 2)
'VE Day 1945' by L S Lowry (no. 9) [parties and celebrations]
'Autumn Leaves' by John Everett Millais (no. 11)
'The Spinning Top' by Torii Kirohiro (no. 14)
'Southwold' by Stanley Spencer (no. 16) [seaside holidays]

In order to focus the act of comparison for children and to lead them into the appraisal and criticism of works made by artists, it is helpful to select for them work that is similar in content but different in its treatment. Reference has already been made to the useful discussion and comparison that might ensue through studying the three paintings of

married couples in the Resources Pack. There are many familiar themes, such as the family group, the self-portrait, the meal, the harvest, mother and child etc., which have been represented by artists in a variety of times and cultures. These lend themselves to interesting study and comparison. Suggestions for and details of such groupings of work are provided in chapter 6.

2.22 POSTMAN
Year 5
Fibre pen

2.23 POSTMAN
Year 5
Fibre pen

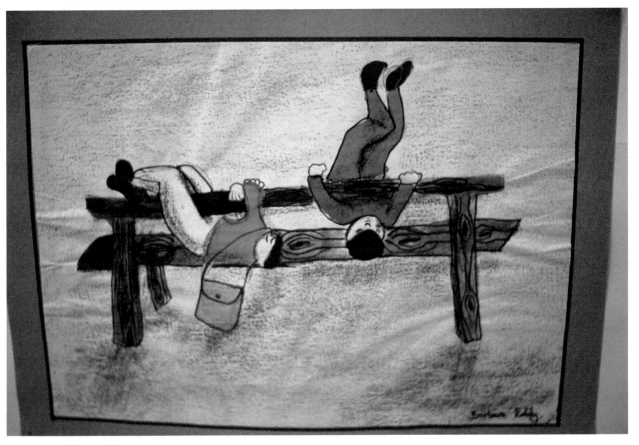

2.24 VAULTING
Year 4
Crayon and felt pen

2.25 BOWLING A HOOP
Year 4
Crayon and felt pen

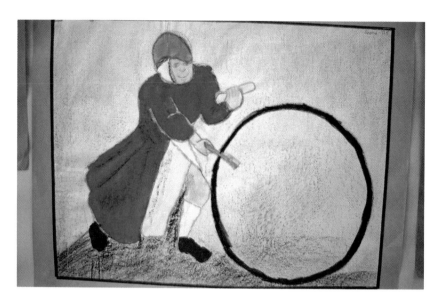

2.26 HIDE AND SEEK
Year 4
Crayon and felt pen

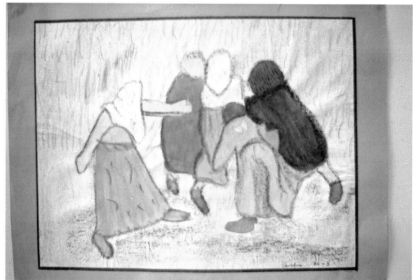

2.27 TOSSING IN THE BLANKET
Year 4
Crayon and felt pen

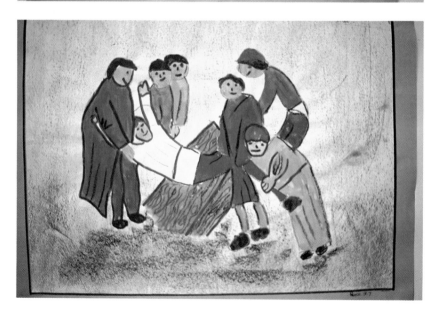

You can also use works of art selectively to help children make comparisons by focusing their attention upon details within more complex works. For example, as demonstrated in figure 2.28, you could ask a group of children to use viewfinders to find as many examples as they can of the way that children are represented in the works in the Resources Pack. Through making studies of these they could, collectively, make some interesting comparisons between the ways that children are portrayed in works made at different times. Using the same collection, you could seek comparisons in the treatment of such other visual forms as trees, weather and dress.

When children are encouraged to take seriously the study of other artists' work, to give them time and to make comparisons between them, they will be well equipped to embark upon the appraisal of work. They will also bring to such appraisal understanding of how the works were made and for what purpose. Such understanding is well illustrated in the writing below by two children in Year 6 who have clearly given careful thought to works by Salvador Dali and Vincent Van Gogh. They were asked to write about the painting like a critic to describe what it looked like, explain how it was painted and to make their own assessment of the work.

'The metamorphosis of Narcissus' by Salvador Dali (The Tate Gallery)

This picture was painted by Salvador Dali and is based on the myth about the metamorphosis of Narcissus who was very vain and who fell in love with his own image. He looked into a pool and turned into a stone hand and then into a flower (which is called the narcissus). There is a city in the background of the picture at the base of lots of rocky mountains. Then there is a chequer board with a pedestal and the vain figure of Narcissus on it. In the foreground there is the dreaded pond with the metamorphosing figure of Narcissus. On the right of him there is a limestone hand holding an egg with a narcissus flower in full bloom coming out of it. Next to the hand is a dog-like animal eating raw meat and a trail of blood leading towards the metamorphosing figure of Narcissus. Also there are lots of giant ants crawling up the hand which has several cracks in it. There also seems to be a track leading from the city to a fiery crater which may be the entrance to Hell. There is a group of possibly vain people right near the edge of the crater. The picture has a space age effect and it looks rather evil and foreboding. I like it because it has a strange fascinating effect and there always seems to be something new to look at.

'Wheat fields at Arles' by Vincent Van Gogh (The Tate Gallery)

This picture reminds me of a wheatfield. It is a windy day and the sky is full of clouds swerving in the air. The bushes and trees are swaying in the wind because the wind is furious and noisy. This

picture has different shades, it gives me a good feeling of what it's like in the country. The rocks are different shapes and sizes. This picture is very interesting because it makes me feel what it is really like and it gives the right looks and feelings. It also has lots of detail. I like the way he has made all the curves and waves. Van Gogh sometimes uses a knife for his painting and when he painted this picture he used a knife and he got some good effects with his knife movements. In this picture the knife movements make the clouds look better and more realistic. It looks real and it feels real.

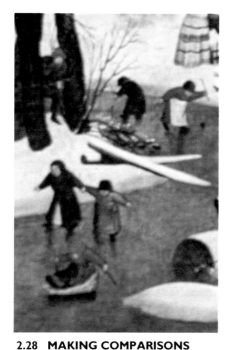

2.28 MAKING COMPARISONS
Using viewfinders to study how children have been represented in different ways in these paintings and prints:
'The Census at Bethlehem' (no. 6)
'Children's Swimming Pool'
 (*Resources Pack no. 2)
'Autumn Leaves' (no. 11)
'The Spinning Top' (no. 14)
'The Cholmondeley Sisters' (no. 3)

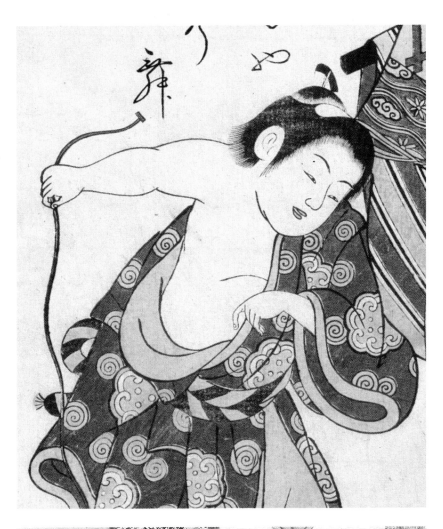

3 Using works of art to inform children's making

3.1 THE ARTIST'S MOTHER
Year 1
Tempera

3.2 THE ARTIST'S MOTHER
Year 1
Tempera

MOVING BEYOND PASTICHE

There has already been some discussion in chapter 1 about the value to children of their making connections between their own work and that of others initially through copying or 'borrowing' ideas from other artists. In the Reception class and in Years 1 and 2, using the system of making a 'pastiche' of another artist's work is a natural and easy way to make these early connections. Figures 1.1 to 1.11 illustrate the different kinds of value that this kind of borrowing can have for children in encouraging them to work in different ways and in establishing links between work taking place in the classroom and in the wider community. Borrowing from other works will support and encourage children in their making of images in response to familiar themes.

Using the same colours

Figures 3.1 and 3.2 are paintings by children in Year 1 made in response to observing and talking about Alberto Giacometti's painting 'The Artist's Mother'. The choice of painting was appropriate both because of its subject matter and because it is freely painted in a limited range of colour. This led to good discussion within the group about the way the work was made. It was a natural follow up then for the children to make their own paintings of their own mothers using similar colours and methods to those used by Giacometti.

There are many artists whose methods of working are particularly evident even in cheap reproductions and postcards. It is comparatively simple to use their work to encourage children to explore different ways of painting and of using and applying paint. To some extent, this accounts for the popular use in schools of work by artists like Van Gogh, Seurat, Matisse, Lowry etc. whose work is easily available in reproduction and whose methods of painting can be easily identified and used. In using such work, there is a fine line between simply presenting the work to children to copy and using it positively to encourage real talk and enquiry about the work, how it was made and how what has been observed can contribute to the children's own making.

Learning about colour

Figures 3.3 and 3.4 are of re-workings by children of two very familiar paintings by Vincent Van Gogh. They are straightforward copies and what value they have rests upon the care and attention the children have given to using colour within the painting and what they have learnt about a painting in making this copy. These particular paintings were chosen as studies because they provided the opportunity to learn about how artists use and apply pigment in their work. Similarly, figures 3.5 and 3.6 are re-workings by children in Year 5 of Turner's famous painting 'Rain, Steam and Speed'. It is evident in these paintings that both the teacher and the children invested a great deal of time in exploring and experimenting with colour mixing and the application of colour in preparing for and making these pastiches.

**3.3 'THE STARRY NIGHT' BY
VINCENT VAN GOGH**
Year 5
Tempera

**3.4 'HARVEST LANDSCAPE' BY
VINCENT VAN GOGH**
Year 4
Tempera

**3.5 'RAIN, STEAM AND SPEED'
BY J M W TURNER**
Year 5
Tempera

**3.6 'RAIN, STEAM AND SPEED'
BY J M W TURNER**
Year 5
Tempera

Although it can be valuable to use artists' work in this way and children can learn a great deal from making a 'copy' of another artist's work, such use of pastiche has to be managed carefully. It was once part of the traditional training of art students that they should make 'a copy from the Masters'. This exercise had purpose in encouraging the student to explore systematically the way that an established painter had made a work, but value only if the student's own work was illuminated by making the copy. It is worth remembering that Vincent Van Gogh, whose work is so assiduously copied in schools, made many copies of drawings and paintings by other artists during his own training. He studied artists whose work he wished to emulate and whose influences he absorbed into his own remarkable and individual way of working.

Making a copy of another work can have value if it is undertaken for a purpose and if, in making the copy, the children's making skills and understanding are moved forward. It is important, however, not to be tempted into using copying and pastiche as an end in itself and as a means to providing children with easy access to making nice pictures. Making a copy may be a natural way to begin exploring other artists' systems, but it is only the first step towards helping children to use other artists' work to inform their own work.

USING ARTISTS' SYSTEMS

In order to use artists' systems effectively to support your teaching you will need to seek ways to help children focus upon those different means that artists use to make their work. Children will learn about painting by looking at paintings, just as they will learn about music by listening to music; but in both cases you will need to help them move behind the image or the tune to explore how the form was constructed.

Drawings, paintings and artefacts are constructed by using different materials and processes in combination and by using these processes to respond to and to describe our visual experiences. In order to do this we have to become familiar with the visual language of Art and Design and to understand how we can make and use different qualities of line and colour, surface and form.

It will be obvious that children can learn a great deal about colour simply by mixing and matching colour and through observing colour in the real world. They will also learn a great deal by looking at the way that other artists have used colour both descriptively and expressively and by the way they use different methods to apply and make colours to obtain certain effects. This is evident in figures 3.5 and 3.6 where the children have been encouraged to explore different methods of mixing and applying colour in response to the study of Turner's paintings.

In the Resources Pack, there are many examples of activities that you can undertake with children to make them aware of the different methods and systems that artists use: as for example in making a colour chart of all the blues and greens used by Henri Matisse in his painting 'Still

life with goldfish' (no. 7); and in experimenting with mixtures of paint and glue to try to paint water using a similar method to that used by Leon Kossof in his paintings of swimming pools (no. 2).

Using Van Gogh's systems

You can introduce children to learning about and using artists' systems in a variety of ways. You can begin by asking the children to make a careful study from a work such as Van Gogh's 'Sunflowers' (figure 3.7). Then move beyond this familiar image to make colour studies of the range of yellows, browns and oranges that can be found in one or two sunflower heads (figure 3.8). Return to making drawings from real sunflower heads to see how the children might use what they have learnt from the study (figure 3.9). Paintings are an invaluable resource for the study of colour, both in its variety of use and in its application. In addition, the work of

3.7 STUDY FROM VAN GOGH'S 'SUNFLOWERS'
Year 2
Pastel and crayon

3.8 COLOUR CHART FROM SUNFLOWER HEAD
Year 2
Pastel and crayon

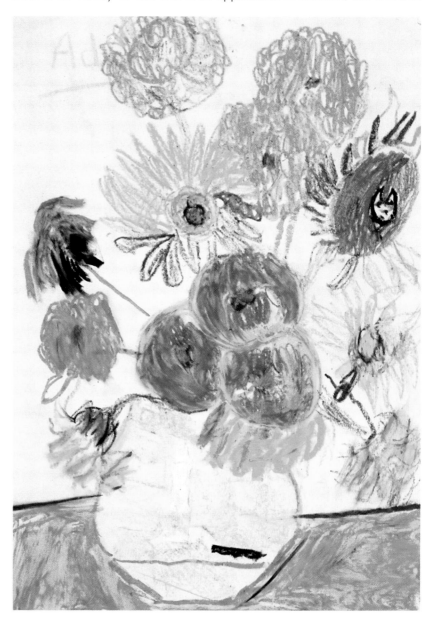

different artists can be contrasted and compared to study how they use and apply pigments in different ways. Even in reproduction, children can observe that Van Gogh, Seurat and Matisse use different methods or systems of painting, different kinds of combinations of colours and different methods to apply pigment to canvas, board or paper.

A particularly useful way to compare artists' systems of painting is to look, for instance, at the way they use different methods to draw or paint from the same source material. Reference was made in chapter 2 to the value of using the Resources Pack to find and study different examples of the way that trees and skies have been represented in this collection. There should also be occasions where through a visit to an exhibition or through borrowing work, you can give children the opportunity to study original paintings and to observe at first hand the differences between paintings made in different media.

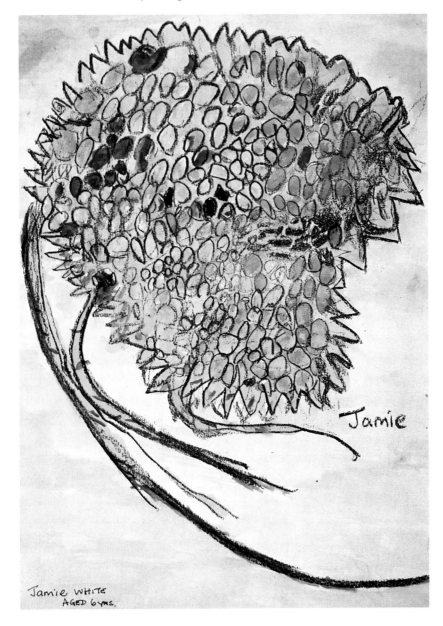

Jamie

Jamie WHITE
AGED 6 yrs.

3.9 DRAWING FROM OBSERVATION OF SUNFLOWER HEAD
Year 2
Micro liner and crayon

3.10 HOW TO DRAW TREES

Photocopies of drawings of trees by different artists.

Using photocopies

Similarly, you can select work from drawings made by various artists to examine the way that artists use different drawing materials and methods for different purposes. Photocopies of reproductions of artists' drawings can be used to help children see the variety of ways that pencil, charcoal, ink and conte may be handled, what range of marks and effects they will make and how these may be used to create different effects within a drawing. Figure 3.10 is a collection of photocopies of details from artists' drawings of trees that would usefully focus children's attention upon the different ways they might approach the task of making drawings of trees in their own local environment. Figure 2.6 illustrates well the variety of mark making that Vincent Van Gogh has used in his drawing 'Landscape at Mont Majour' (Resources Pack no. 13).

Figure 3.11 is a worksheet prepared by one teacher to use with a class of children to help them investigate Van Gogh's drawing systems in preparation for their making their own drawings from the local seascape. The use of such reference materials or worksheets will help children to see how they can use other artists' systems to inform their own work. In the next chapter, there are further examples of worksheets which were designed to support a visit to see work in a local gallery.

You can use the knowledge and experience that children gain through studying artists' systems in a variety of ways. As in some of the work already illustrated in this book, knowledge about how artists paint and draw will directly support the children's own drawing and painting. The more that children know about the different ways that paint and drawing

3.11 DRAWING SYSTEMS WORKSHEET

Prepared by a teacher to support children's enquiry into Vincent Van Gogh's use of different marks in his drawings.

The Sea at Saintes-Maries: Van Gogh

In this pen and ink drawing Van Cogh uses several tricks to give an impression of depth: lines of diminishing size and variety and less detail on the distant boats. Van Gogh has used the media to make marks which create at texture, and those textures together give an impression of the sea.

In the boxes below use pen and ink to explore the different textures or marks that Van Gogh uses in his drawing. Then explore how many textures you can make.

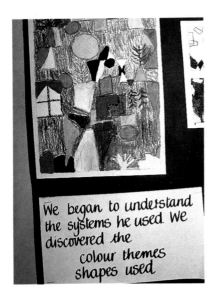

We began to understand the systems he used. We discovered the colour themes shapes used

3.12 ANALYSING PAUL KLEE'S USE OF LINE, SHAPE AND COLOUR
Year 5
Coloured pencils and pastel

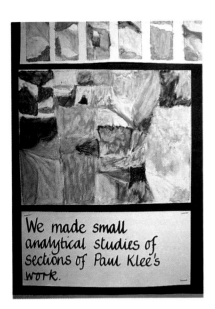

We made small analytical studies of sections of Paul Klee's work.

3.13 ANALYSING PAUL KLEE'S USE OF LINE, SHAPE AND COLOUR
Year 5
Coloured pencils and pastel

3.14 ANALYSING PAUL KLEE'S USE OF LINE, SHAPE AND COLOUR
Year 5
Coloured pencils and pastel

materials may be used, the better equipped they are to respond to a variety of subject matter and resource material. They are also more likely to begin to choose and develop their own systems of working simply because such knowledge extends their understanding of the possibilities of image making.

Using Paul Klee's systems

There has been criticism in the past of teaching drawing and painting didactically, as in those 'How To Draw' books which show children the 'right' way to draw or paint a tree, a cat or a face – or anything else. Such criticism is directed at the notion that there is only one correct way to draw or paint anything. As has been so clearly demonstrated in *Investigating and Making in Art* (Part I), there are many different and equally valuable ways that children can draw and paint and a variety of methods and systems they can use to match different tasks.

In teaching children to be familiar with the different systems that artists' use, you will also be helping them to become familiar with the variety of ways that the visual language of Art may be used and applied across a range of art and design disciplines. The knowledge that children acquire about colour in studying and making a painting can be applied equally to making a weaving; knowledge about pattern and surface that may be achieved through making a drawing can be used equally in making a print or a batik.

This cross-reference of using systems across art and design disciplines is well illustrated in figures 3.12 to 3.17. In this work, children in Year 5 began by making studies of paintings by Paul Klee. They analysed the artist's use of line, shapes and colour by making analytical studies of sections of his paintings (figures 3.12/3.14). Then they applied similar systems to the observation of their own environment (figures 3.15/3.16), before translating their studies into works in ceramic and batik (figure 3.17).

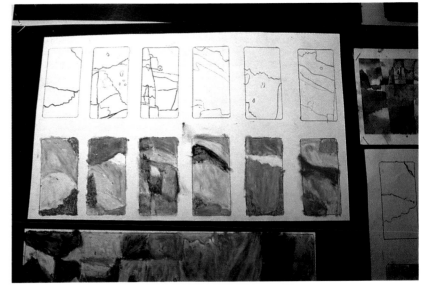

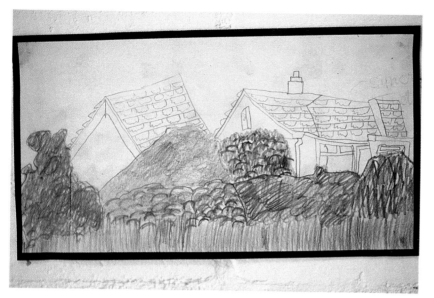

3.15 OBSERVED DRAWING OF LOCAL HOUSES
Year 5
Pencil

3.16 DRAWING OF LOCAL HOUSE USING KLEE'S DRAWING SYSTEM
Year 5
Pencil

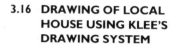

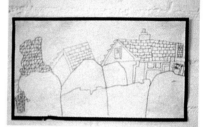

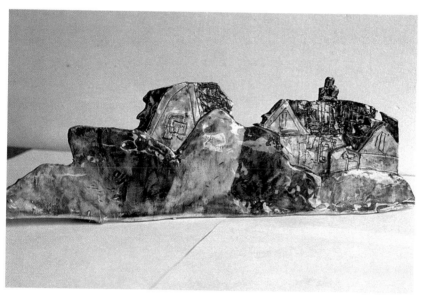

3.17 ROW OF HOUSES
Year 5
Ceramic

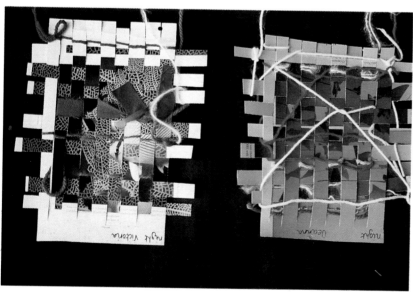

3.18 EXPERIMENTAL 'NIGHT TIME' WEAVING
Year 3
Papers and materials

Using a weaver's methods

In another school, children in Year 3 used the experience of working with a weaver in residence to design and make their own weavings using the same methods employed by the weaver. Like her, they observed colours at different times of the day, made experimental weavings from the colours they made and collected (figure 3.18) and experimented with different wools and materials (figure 3.19). Then they made their own sunrise, morning, afternoon or evening weavings (figure 3.20).

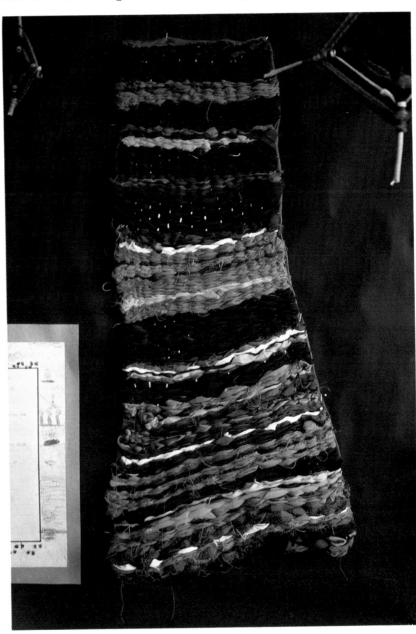

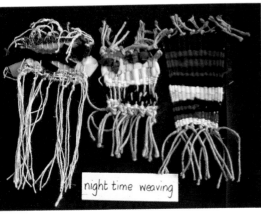

3.19 EXPERIMENTAL WEAVING
Year 3
Wool and materials

3.20 'NIGHT TIME' WEAVING
Year 3
Wools and materials

Using the influences of others

It is an appropriate and interesting challenge to try to help children see how the work of one artist may be influenced by the systems and methods used by another. There are some very obvious examples you can use with children: for example, comparing the drawings of peasants made by Jean-Francois Millet with those made by Van Gogh; or comparing some of Pablo Picasso's cubist paintings with African carvings. All artists are influenced by others and draw many of their ideas and inspirations from the study of the work of other artists and designers. In the Resources Pack there are many examples of cross-references between the work of artists to illustrate these influences.

One area that appeals to children is the study of character and caricature. By studying an artist's work they can investigate how the artist simplifies and caricatures the appearance of characters in their drawings and paintings. They can then reconstruct these characters in other materials.

Figures 3.21 to 3.26 illustrate how children in Year 5 were introduced to the work of the artist Beryl Cook, through first investigating the way that other artists have simplified and caricatured the appearance of people in their own work (figures 3.21 and 3.22). They then made studies from Beryl Cook's work to see how she makes the characters in her paintings so amusing by simplifying and exaggerating their appearance (figures 3.23 and 3.24). Finally, the children used these studies to reconstruct some of these characters in different materials (figures 3.25 and 3.26).

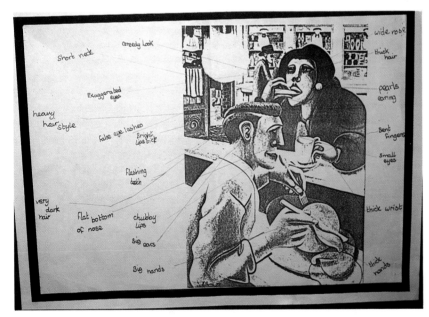

3.21 STUDY OF DETAILS OF CHARACTERS IN 'THE SNACK BAR'
Edward Burra, 1930 (Tate Gallery, London)
Year 5

3.22 STUDY OF DETAILS OF CHARACTERS IN 'THE SNACK BAR'
Edward Burra
Year 5

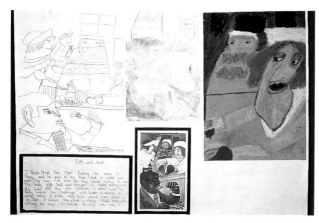

3.23 STUDY OF DETAILS OF CHARACTERS IN BERYL COOK'S WORK
Year 5

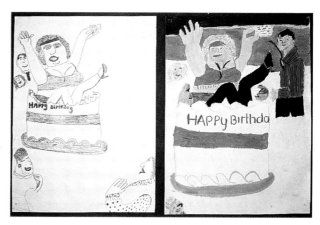

3.24 STUDY OF DETAILS OF CHARACTERS IN BERYL COOK'S WORK
Year 5

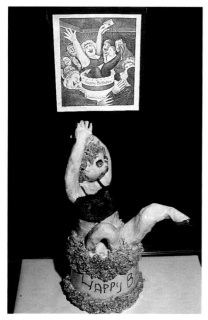

3.25 'HAPPY BIRTHDAY'
Year 5
Ceramic

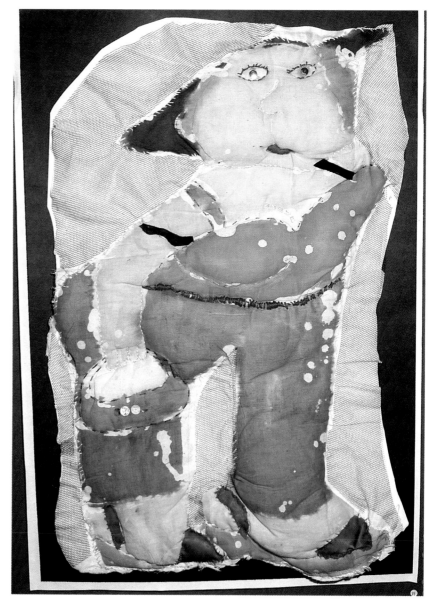

3.26 'FAT LADY'
Year 5
Quilting, embroidery and batik

RECONSTRUCTING WORKS OF ART

Because works of art are in themselves reconstructions by artists of some reality they have themselves perceived and responded to, it can be useful to return to and reconstruct that source material the artist worked from. For children, this can be a helpful way into seeing a painting for what it is — the artist's two-dimensional equivalent for something experienced in three dimensions. The painter views the three-dimensional world and translates it into a two-dimensional image: the painting is an equivalent in pigment to something that he or she has observed and responded to in the real world.

You can begin by challenging children to reconstruct, in three-dimensional materials, an image they see in the painting. To do this effectively, they need to begin by making studies from the painting to become familiar with the form they are to reconstruct (as in figures 3.25 and 3.26). Figure 3.27 is the painting 'Mr and Mrs Clark and Percy' by David Hockney and figure 3.28 shows a version of this painting made by a child in Year 4 after writing the following description of the painting:

> The room that this couple live in looks bare because there is not much furniture. That might be because they have just moved in and they haven't got all their furniture in yet. I don't think the man cares much about his health because he is smoking. He is about 31 and he likes green and flared trousers.
>
> The cat looks proud of itself because he is sitting up straight. The cat is being obedient and he is looking out of the window by the balcony.
>
> The lady looks happy and she looks as though she has just had her breakfast and just got out of bed. She must care what she wears because she is wearing a posh dress.
>
> I don't like this picture much because it is dull. I would like it if it had more windows and a lot more light. And the people should look more lively.

After writing this description and making the drawing of the painting the work was reconstructed (figure 3.29) using a variety of found materials and plasticine.

Similarly, a group of children in Year 5 working together made large-scale studies from one of L S Lowry's paintings of industrial landscapes and then built the landscape in clay (figures 3.30 and 3.31). This kind of work is one way of helping children to understand and respect the convention of making an image on a flat surface from observation of natural and made forms in three-dimensional space.

Another way into a painting is to reconstruct for them something equivalent to the visual experience the painter worked from in making the painting. This is particularly easy to do with simple subject matter such as a still-life painting or the painting of a single figure. The two still-life paitings by Henri Matisse and Pablo Picasso that are in the Resources

**3.27 'MR AND MRS CLARK AND
PERCY'**
David Hockney, 1970–71 (The
Tate Gallery)
*Resources Pack no. 12

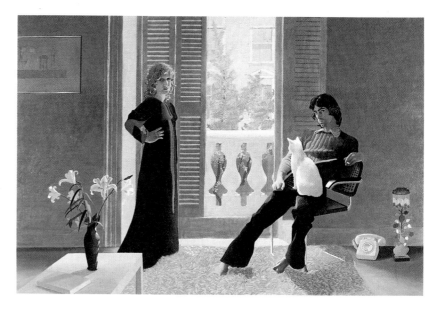

**3.28 MR AND MRS CLARK AND
PERCY**
Year 4
Crayon and pencil

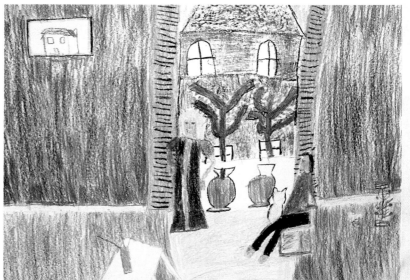

**3.29 MR AND MRS CLARK AND
PERCY**
Year 4
Mixed media

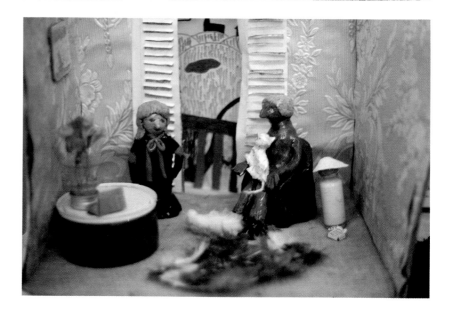

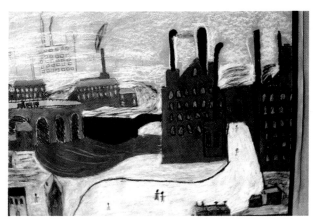

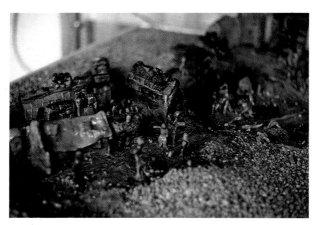

3.30 INDUSTRIAL LANDSCAPE
Year 5
Chalk, charcoal and pastel
Studies from a painting by
L S Lowry.

3.31 INDUSTRIAL LANDSCAPE
Year 5
Ceramic
Group work based on studies
from paintings.

Pack (numbers 7 and 10) would be simple to reconstruct in the class-room. It is a valuable experience for children to be able to observe Matisse's painting alongside a reconstruction of his subject matter. Such experience would lead to very valuable discussion about how the painting was made and how its appearance compares with its subject matter. The children would become aware of the way that an artist selects from the source material, simplifies what they see, and focuses upon particular qualities within such a group of familiar objects. It would be a natural follow up to make their own work from the same source material and to consider how they themselves make selections and choices from things they see when making a painting.

Reconstructions of a painting

In the Resources Pack there are a number of suggestions for ways in which you can reconstruct for the children passages within the works represented, so that you can help them to understand how the work was made. For example:

- Using house plants and tropical plants to create a jungle like that in Henri Rousseau's painting 'Tropical Storm with Tiger' (no. 1).
- Using a selection of natural forms to make 'table top' land-scapes like those used by Thomas Gainborough in his own work (no. 19).
- Reconstructing the washing line of towels and bathing costumes that can be seen on Stanley Spencer's painting 'Southwold' (no. 16).
- Dress and pose children as though they were sheltering against the weather like the central figures in Ford Maddox Brown's painting 'Last of England' (no. 15).

All such reconstructions help children to better understand how artists make work in that they are able to make real comparisons between the subject matter or content of the painting, how the artist has dealt with the theme and how they were able to respond to the same theme. Figures 3.32 to 3.34 show children working from the teacher's reconstruction of a Victorian painting of a women seated at a table.

Figure 3.35 shows Philip Wilson Steer's painting 'Girls Running on Walberswick Pier' made in 1894. The following illustrations show how a teacher working with a Year 2 class encouraged the children to reconstruct this painting imaginatively. They began by making detailed studies from the painting, drawings of the figures and studies of the way that colours are used in painting the sea and the sky (figure 3.36). They then made a three-dimensional model of the painting (figure 3.37). Finally, the children made their own paintings of the girls running along the pier from their own reconstruction (figure 3.38).

3.32 SEATED FIGURE AT A TABLE
Year 6
Child dressed and posed to reconstruct the key figure in the painting.

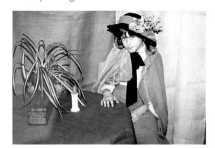

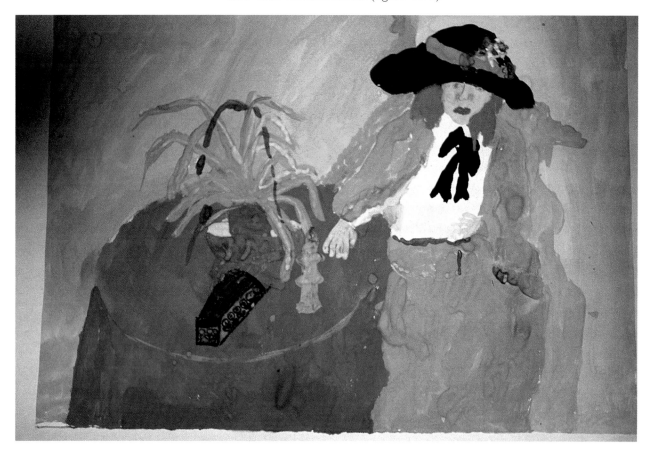

3.33 SEATED FIGURE
Year 6
Tempera

3.34 SEATED FIGURE
Year 6
Tempera

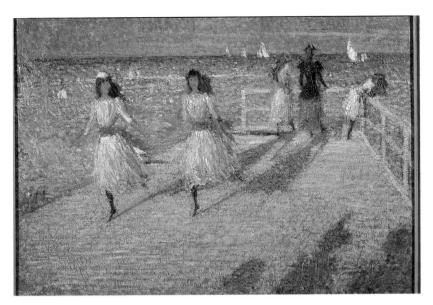

3.35 'GIRLS RUNNING ON WALBERSWICK PIER'
Philip Wilson Steer (The Tate Gallery)

3.36 COLOUR STUDY FROM THE PAINTING
Year 2
Tempera

3.37 MODEL OF THE PAINTING
Year 2
Mixed media

3.38 GIRLS RUNNING ON THE PIER
Year 2
Tempera
Painting from the model

EXTENDING THE POSSIBILITIES OF IMAGE MAKING

This last example shows how you can begin to use works of art imaginatively to extend children's understanding of the possibilities of image making. There are many occasions in the school year when you will necessarily want the children to work on familiar themes which they will have worked on. The school calendar includes many ritual occasions that you may wish the children to celebrate visually, such as Easter, the harvest festival, Hallowe'en and Christmas and similar festivals in other cultures. It is all too easy in these circumstances to resort to such familiar stereotypes as the Easter chick, the broomsticked witch and the Christmas tree as source materials, especially since these stereotypes dominate the commercial celebration market.

Where you need to ask children to work on such familiar themes as these it is worth considering how you can use works of art to help

3.39 'AUTUMN LEAVES'
John Everett Millais (Manchester City Art Gallery)
*Resources Pack no. 11

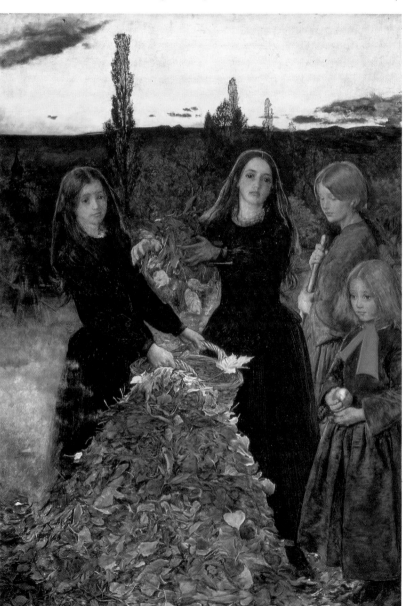

3.40 THE BONFIRE
Year 3
Tempera

children to see the range of visual possibilities within these themes. For example, hundreds of artists over the years have painted, carved and sculpted the Angel of the Annunciation. You could help children to see the variety of ways that angels might be represented by studying some of these works and using them as source material for your work at Christmas. Christmas is also a great time for feasting; and feasting is richly illustrated in many works, as various as Bruegel's paintings of peasant feasts and Mrs Beeton's Book of Household Management.

These illustrations show how a teacher used Millais's painting of 'Autumn Leaves' (figure 3.39) to help children in Year 3 see how they might approach the task of making a painting to celebrate 'Bonfire Night'. In addition to studying the painting, the children – like Millais himself – made careful colour studies of the leaves they collected for their own school bonfire before making their own bonfire paintings (figures 3.40 and 3.41). In another school, a teacher used Van Gogh's painting 'Starry Night' with its great explosions of colour in the sky to help children see how they might enliven the routine task of painting the same theme.

Other familiar and favourite themes for children's paintings are such subjects as the circus and the jungle which children will see represented many times in storybook illustrations and for which there are familiar conventions. Most children when asked to draw or paint a clown from recollection will resort to making that familiar stereotype of the clown's face. If you show them good photographs of the different kinds of disguises that clowns adopt and relate these to paintings of clowns and circuses by Toulouse-Lautrec or Georges Seurat, the children will be more likely to see possibilities beyond the stereotype figure of the acrobat or clown. Then they may make more inventive and expressive images of the circus.

3.41 THE BONFIRE
Year 3
Tempera

3.42 DISPLAY OF ROUSSEAU'S PAINTINGS

Study of tropical paintings by Henri Rousseau

Figures 3.42 to 3.48 illustrate the work by children in Year 4 who were working on a jungle theme in association with a class topic. The teacher not only took the children to visit a tropical house in the local zoo, but also used a selection of Henri Rousseau's magical paintings of jungles to open up for the children the range of possibilities present within the theme.

In this kind of way, you can use other artists' work, not only to inform children about ways they might make their work, but also to key them into those expressive and imaginative possibilities present within the theme.

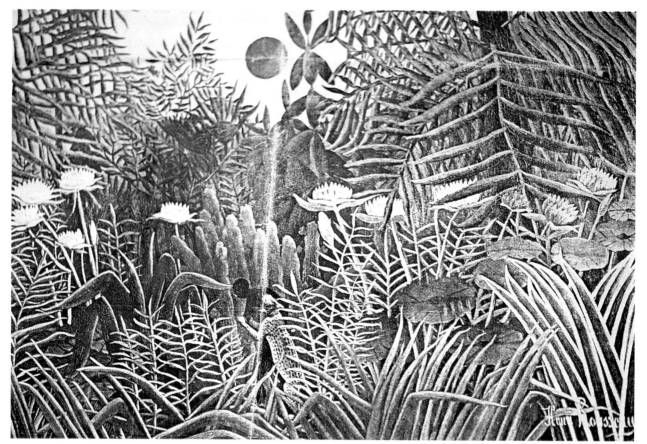

3.43 DETAIL OF DISPLAY: PHOTOCOPY OF JUNGLE DETAIL

3.44 JUNGLE STUDY
Year 4
Micro liner

3.45 JUNGLE STUDY
Year 4
Pencil

3.46 JUNGLE STUDY
Year 4
Watercolour

3.47 THE JUNGLE (DETAIL)
Year 4
Tempera

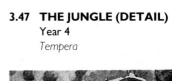

3.48 THE JUNGLE – GROUP PAINTING
Year 4
Tempera

Critical studies across the curriculum

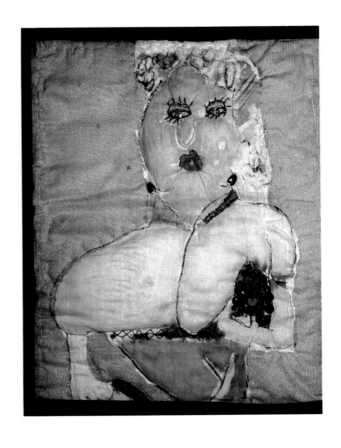

USING WORKS OF ART AND DESIGN ACROSS THE CURRICULUM

The use of Art and Design across the curriculum has already been addressed in *Principles and Practice* chapter 5, where the working relationships between Art and Language, between Art, Science and Technology, between Art and the Humanities and across the Arts were discussed in some detail. Within the Teacher's Guide to the Resources Pack there are also examples of ways in which some of these reproductions can be used as reference and source material in asociation with such cross-curricular themes as 'Our families', 'Colour and light' and 'Protection'.

It should have already been established in this book how important it is to children to study the work of other artists in order to become more informed about ways in which they might approach the making of their own work. In doing this, not only do they become more knowledgeable about how work is made, they are also made more aware of the possibilities of visual language and expression.

The study of the work of other artists and designers is also important to children because their work provides such rich evidence of the various ways that artists have responded to such a wide variety of human experience over many thousands of years and in many different cultures and circumstances. Artists have described with loving care the appearance of their own familiar environments and the people they have known; they have represented great and small occasions in history; they have used their skills and understanding to comment upon and to express their feelings about things they have seen and experienced. Artists, craftworkers and designers have helped to shape our civilisations through the images and artefacts they have made and through the buildings and environments they have designed and constructed.

Within the Resources Pack there are works like Paolo Uccello's 'The Battle of San Romano' (no. 21) and L S Lowry's 'VE DAY 1945' (no. 9) which describe and celebrate great historical occasions. There are others like Vanessa Bell's 'Interior with table' (no. 22), and Pablo Picasso's 'Still life with fish' (no. 10) which are domestic in scale and illuminate everyday events and appearances. There is other work like Henri Rousseau's 'Tropical Storm with Tiger' (no. 1) and Paul Klee's 'A Girl's Adventure' (no. 4) which are more inventive than descriptive and which express the artist's ideas and feelings about their experiences.

It should therefore be apparent that the study of the works of artists and designers will be valuable in support of other areas of study and learning in the primary school curriculum. Children will benefit through having access to real evidence of the way that artists have influenced and have helped to shape the world in which we live.

THE INTRIGUING IMAGE

In *Principles and Practice*, there are some examples of children's work made in response to the study of the poems 'Hiawatha' and 'The Rime of the Ancient Mariner'. They illustrate how some stories and poems are so powerful in their description of events and so evocative of atmosphere that they can in themselves generate an exciting visual response from children. The same truth may be observed in reverse in that there are some images made by artists that are intriguing enough in themselves to generate exciting language responses from children. Some images will generate response because of their intriguing unfamiliarity, some because of the dramatic events they portray, some because of how powerfully they recreate for us familiar occasions and events. There are examples of all of these in the Resources Pack that will lend themselves to an exciting interplay between image and language and real opportunities for cross-curricular work between Art and English.

There are, for example, interesting opportunities for comparing the way that artists and poets have responded to similar subject matter. Henri Rousseau's 'Tropical Storm with Tiger' (figure 4.1) may usefully be placed alongside the first verse of William Blake's poem 'Tiger':

> Tiger! tiger! burning bright
> In the forests of the night,
> What immortal hand or eye
> Could frame thy fearful symmetry?

Such juxtaposition will enhance the children's perception of both image and poem and will encourage and extend their own written responses to such a dramatic theme.

In gentler vein, there is a nice visual and language parallel between John Everett Millais's 'Autumn Leaves' (figure 3.39) and Laurence Binyon's poem 'The Burning of Leaves':

> Now is the time for the burning of the leaves.
> They go to the fire; the nostrils prick with smoke
> Wandering slowly into the weeping mist.
> Brittle and blotched, ragged and rotten sheaves!
> A flame seizes the smouldering ruin, and bites
> On stubborn stalks that crackle as they resist.

Millais's painting and representation of autumn can also be placed alongside Stanley Spencer's rendering of high summer in 'Southdown' (Resources Pack no. 16) and any of the many poems about being by the seaside on holiday. These can encourage children to draw upon their own experiences of the seasons in their writing of prose and poetry.

Many works by artists can be used in different kinds of groupings to build upon and to extend both children's descriptive and expressive responses to familiar themes. As was illustrated in chapter 2, works of art can be used to generate both good descriptive and compara- tive writing. The study of the three works in the Resources Pack

4.1 'TROPICAL STORM WITH TIGER'
Henri Rousseau, 1891
(The National Gallery, London)
*Resources Pack no. 1

which describe family grouping in the 18th, 19th and 20th centuries respectively – Gainsborough's 'Mr and Mrs Andrews' (no. 19), Maddox Brown's 'Last of England' (no. 15) and Hockney's 'Mr and Mrs Clark and Percy' (no. 12) – could be used to support good comparative writing about differences in appearance, differences in dress and possessions and perceived differences between family life at different times. The same three works could also be used to generate more speculative and personal writing about what kind of people are portrayed in these paintings, what kind of lives did they lead, and what might they have experienced in their everyday lives.

Some works will intrigue children because of their apparent unfamiliarity, strangeness or ambiguity. What kind of adventure is the little girl having in Paul Klee's painting (figure 4.2)? What is the subject matter of Georgia O'Keefe's painting 'Blue and Green Music' (figure 4.3)? There are many other symbolic or abstract paintings that can be used to encourage children to write speculatively or to puzzle their way through to a satisfactory reading or solution.

Some works will intrigue children because of the stories they tell and which they can respond to personally and with some feeling. Paintings like 'The Doctor' by Sir Luke Fildes which portrays the Victorian doctor

4.2 'A GIRL'S ADVENTURE'
Paul Klee, 1922
(The Tate Gallery)
*Resources Pack no. 4

4.3 'BLUE AND GREEN MUSIC'
Georgia O'Keeffe, 1919
(The Art Institute of Chicago)
*Resources Pack no. 23

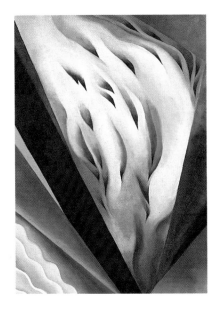

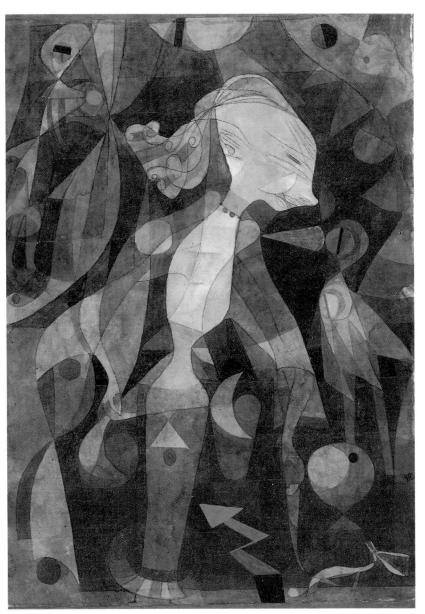

at the sick bed of a small child being anxiously observed by the child's mother, will recall for the children similar concerns about sickness. When work like Ford Maddox Brown's 'Last of England' (no. 15) is placed in context for children, they too will appreciate and respond to the cares of a family about to embark upon a dangerous voyage to a new world and an uncertain life.

You can also use works that are descriptive and familiar in their subject matter to generate personal writing by encouraging the children to use them selectively and to seek within them passages or detail that they find intriguing. The writing below came from a group of children in Year 5 who used viewfinders to seek interesting sections within the painting 'Girls Running on Walberswick Pier' by Philip Wilson Steer (figure 3.35). They made studies from the chosen detail and then wrote freely about the image they had selected and about the atmosphere and feeling it conveyed.

4.4 THE FACELESS LADY
Year 5
Tempera and pastel

4.5 THE LONELY ROCK
Year 5
Tempera and pastel

The Faceless Lady

> Can you see the rushing sea today or the yellow sand?
> All you can see is the black night.
> If you had a pair of eyes, you could see what others see.
> If you had a mouth you could speak to me now and then.
> Everybody calls you Mrs Faceless Lady.
> You can't tell anyone what your name is.
> I feel sorry for you Mrs Nobody. (Figure 4.4)

The Lonely Rock

> The whitish rock all alone, standing in the clear blue sea,
> As a gentle breeze went calmly by.
> But the rock just stood there
> With the water gently splashing on its side.
> In the prison of the clear blue sea. (Figure 4.5)

In using works of Art and Design to link image making and the use of language you extend children's understanding of the power of images and of the ways that they can be used to convey meaning.

INVENTIONS AND ARTEFACTS

The working relationship between Art and Design and Technology is discussed in chapter 5 of *Principles and Practice*, principally to establish and identify the processes that are common within the Attainment Targets for both subjects. The study of Technology is very concerned with the way that we design, make and shape artefacts, systems and environments in response to the needs of our societies and cultures. It can therefore be seen that there will be many and useful occasions when Art and Technology will draw upon common starting points and resource materials in order to seek evidence of the way that other craftworkers and designers have responded to the challenge of resolving a range of designing and making problems.

Artists and designers working in past times provide graphic evidence of the early application of different technologies to sustain, house, clothe and protect human life and society. The cave paintings at Lascaux show how the early tribes fought and hunted. The Bayeux Tapestry provides rich evidence of how the Saxons and Normans were housed, how they farmed and with what tools and implements, and how they used technologies in the implementation of war against each other. Medieval illuminated books contain detailed illustrations of craftworkers and builders. Painters working in the 18th and 19th centuries provide detailed accounts of the onset and effect of the industrial revolutions upon our society. In more recent years, Stanley Spencer's monumental paintings of 'Shipbuilding on the Clyde' (in the Imperial War Museum, London) and Fernand Léger's series of works about the construction industry are both important documentaries about industrial life and work before the computer revolution.

The sketchbooks and notebooks kept by designers, craftworkers and inventors are valuable source material in providing evidence of the way that ideas are proposed and solutions sought. Leonardo da Vinci's notebooks are now easily available in facsimile and have been used by some schools to help children see how a great inventor approached a range of tasks from designing a machine for shaping iron rods to proposing a flying machine. (Examples of children responding to Leonardo's ideas are illustrated in *Principles and Practice* chapter 4, figures 4.36 to 4.39.)

In the Teacher's Guide to the Resources Pack there are many examples of linking activities between Art and Technology that will grow out of the study of works of art and design in the Resources Pack. For example:

- Using 'The Cholmondley Sisters' (no. 3) to look at the design of costumes and jewellery; and designing and making crowns based upon the study of other Elizabethan paintings.

- Using Kiyohiro's 'The Spinning Top' (no. 14) to consider both the design of different kinds of printing blocks and of familiar toys.
- Using Paolo Uccello's painting 'The Battle of San Romano' (no. 21) and Elizabeth Frink's sculpture 'Goggle Head' (no. 18) to generate enquiry into the design of protective headgear for different occasions and for different purposes.

Artefacts

Every community contains a whole range of familiar artefacts made at different times which can be collected and studied. They help the children to see the changes that take place in the design and appearance of everyday objects over a period of time. You can study such artefacts as toys, teapots, sewing machines, hats, chimney pots, door knockers, fabrics and musical instruments made in different times and places. This will help children to begin to understand how the appearance of these familiar forms is influenced by both the fashions and taste of the time and by changes in the way they are made through developing technologies.

Figures 4.6 to 4.9 show studies made by children from teapots, tableware, fabrics and from a facsimile of a Saxon helmet. The study of these real objects can usefully be cross-referred to evidence we have of their appearance in previous times through the work of artists. For example, studies of the metal helmets worn by the soldiers in Uccello's painting can be compared with studies of contemporary helmets worn by builders and motorcyclists, which are formed from plastics. Figures 4.10 to 4.12 are studies of suits of armour made by children in Year 5 who then went on to compare these 'protective outfits' with the 'wet suits' worn by underwater explorers today.

4.6 STUDIES OF A TEAPOT
Year 3
Mixed media

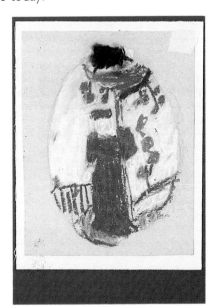

4.7 VICTORIAN PEPPERPOT
Year 2
Pastel

4.8 STUDY FROM A VICTORIAN FABRIC
Year 6

**4.9 STUDY FROM FACSIMILE
OF SAXON HELMET**
Year 3
Pencil

**4.10 STUDY OF ARMOUR
JOINTING**
Year 5
Biro

4.11 DETAILS OF ARMOUR
Year 5
Pencil

**4.13 COLLECTION OF
ARTEFACTS**
Year 5
Mixed media

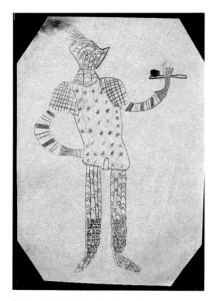

4.12 SUIT OF ARMOUR
Year 5
Biro

It is also important that children be given the opportunity to study the artefacts made in other cultures and to compare the work of craft-workers and designers working in different communities. Figures 4.13 to 4.15 show classroom collections of artefacts from other countries used for study.

4.14 COLLECTION AND STUDIES OF CERAMICS
Year 5
Mixed media
Studies of painted majolica ware from Spain.

4.15 STUDIES OF CERAMICS
Year 5
Mixed media
Studies of painted majolica ware from Spain.

A Victorian kitchen

Where children are encouraged to explore the changes that take place in the design and appearance of everyday artefacts through the study of the work of craftworkers and designers is linking work across Art and Design, Technology and History. The work illustrated in figures 4.16 to 4.20 was undertaken as part of a History based project about the Victorians. The class teacher reconstructed a Victorian kitchen in a corner of the classroom using a wide variety of artefacts collected and borrowed from people in the local community (figures 4.16 and 4.17). The children made studies from these, from Victorian genre paintings and from photographs of other kinds of rooms in Victorian houses. This led them on to designing and making models of typical rooms in a Victorian house (figures 4.18 to 4.20).

**4.16 RECONSTRUCTIONS OF
VICTORIAN ROOMS IN
THE CLASSROOM**
Year 6

**4.17 RECONSTRUCTIONS OF
VICTORIAN ROOMS IN
THE CLASSROOM**
Year 6

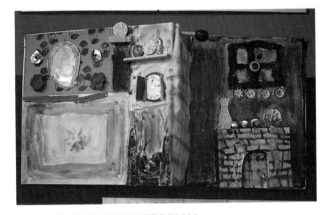

**4.18 DESIGNS FOR VICTORIAN
KITCHENS**
Year 6
Mixed media

**4.19 DESIGNS FOR VICTORIAN
KITCHENS**
Year 6
Mixed media

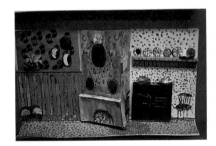

**4.20 MODEL OF VICTORIAN
KITCHEN**
Year 6
Mixed media

HISTORICAL EVIDENCE

The study of images and artefacts made in past times and in other cultures is an important element in developing closer working links between Art and Technology. It will also reinforce our understanding of the way that communities have been shaped by the work of artists and designers over the years.

In the development of the National Curriculum generally, in many subjects, there has been an emphasis upon rooting children's learning within real learning activities and real experiences. In Science there is an emphasis upon children undertaking practical and scientific enquiry; in Geography there is a requirement that all children should undertake some practical field work; work in Technology requires that all designing

and making tasks should take place within a real social context where children should identify the opportunities for designing and making within the environment of home, school and community.

An important development in the teaching of History has been in the requirement that children should have access to and use real historical evidence of the way that communities and cultures have worked and developed. Much of that historical evidence rests within the work of artists, craftworkers and designers. We can learn a great deal about the past through studying the images, artefacts and environments that have been made by artists and designers in past times. Within our own communities, we have easy access to artefacts, buildings and environments that will inform us about the way that they have developed and changed over the years; a walk along almost any high street can lead to an interesting study of the contrast between the contemporary shop fronts at ground level and the facades above; local museums contain interesting evidence in documents, photographs and artefacts of the changes that have taken place within that community.

In addition to having such first-hand evidence of our past in your own community, there is a rich and detailed documentary record of life in past times and in many cultures through the work of artists and designers. Such evidence is all the more immediate through being contemporary to the event portrayed. The Bayeux Tapestry, which was made within a few years of the Battle of Hastings in 1066, is a detailed and contemporary record of the way that the Saxons and Normans lived their daily lives, worked, feasted and prepared for and fought their battles. Its authenticity and power as a record of life in the 11th century is absolute and far more telling than could be any attempt by an artist in the 20th century to describe that great event.

There are a number of works within the Resources Pack which are as valuable to you as documentary evidence of the life and times of the artist as they are as works of art in their own right. Uccello's 'The Rout of San Romano' (no. 21) and Breugel's 'The Census at Bethlehem' (no. 6) provide detailed evidence of domestic life and warfare in the 15th and 16th centuries. You can trace changes in family life and custom in England through the study of those paintings by Gainsborough (no. 19), Ford Maddox Brown (no. 15) and Hockney (no. 12). Daily life in other cultures is illustrated in the works from the Benin, Mughal and Japanese civilisations.

Linking History with Art and Design

This emphasis upon using historical evidence in the Programmes of Study for the National Curriculum in History establishes strong links between Attainment Target 2 in Art 'Knowledge and understanding' and Attainment Target 3 in History, 'The use of historical sources'. The National Curriculum in History requires that all children should study the history of particular cultures and communities in **Key Stage 1** and **Key Stage 2** and in some kind of logical sequence. This is in marked contrast to much

previous practice where historical events were studied randomly in many schools. It was not unknown for children to 'do' the Romans two or three times with different class teachers as they moved through the primary school. Establishing a more coherent pattern for the study of History will enable you and your colleagues to put into place those resources and reference materials relating to the work of artists and designers, craftworkers and architects. This will make a good match between the requirements of the Programmes of Study for both Art and History.

In **Key Stage 1** in History, children should be given a sense of historical awareness through stories and accounts of historical events from different times and cultures, including myths and legends, eyewitness accounts of historical events, stories and fiction and through studying the lives of famous men and women including artists. In this work they will be able to refer to and compare the way that such events are described in stories and fiction with their illustration in drawings, paintings and sculpture. They will be encouraged to compare the events in their own everyday lives with those in the past; as, for example, in comparing their daily life at school and the games they play with the life of school children in past times which are well documented in paintings and drawings. They will also be able to compare their own family lives with family life in other times and cultures through the study of works of Art and Design.

In **Key Stage 2** in History, children are required to work their way through the following core study units:

- Invasions and settlements (by the Romans, Anglo Saxons, Celts and Vikings)
- The Tudors and Stuarts (monarchs and courts, architects and voyages)
- Victorian Britain (buildings and public works, family life, art and photography)
- Britain since 1930 (1939–45 war, popular culture and fashion, cinema and television)
- Greece (art and architecture, the legacy of Greece).

In addition, there are a number of supplementary study units which you may choose to work through with children. These include:

- the study of such themes across time as houses, places of worship, writing and printing, domestic life
- local history, cultural events and occasions
- a non-European culture such as Egypt, Mesopotamia, Assyria, Maya and Benin.

All these History study units provide opportunities for you to use the work of artists and designers as real evidence of daily life in these different times and cultures. You can then make a purposeful match between the children's work in Art and Design and that in History.

Figures 4.21 to 4.24 illustrate the straightforward use of the work of artists and illustrators to collect evidence about the appearance of his-

torical figures and their times. In figures 4.21 and 4.22, children have referred to paintings of the period to record the appearance and design of costume worn by people in the Tudor and Stuart periods. In figures 4.23 and 4.24, children have researched a number of historical sources to illustrate famous voyages and explorations.

Figures 4.25 to 4.27 are studies by children in Year 5 which they have made in association with a History study unit about life in Victorian Britain. They have used Ford Maddox Brown's painting 'Last of England' (Resources Pack no. 15) as the focus for their exploration of both Victorian family life and the reasons for the mass migrations from this country to the United States of America and Australia in the latter part of the 19th century.

Figures 4.28 and 4.29 show work made by children in Year 4 in association with the study of the 1939–45 war. They used archive material fron the local newspaper to recreate the effect of the blitz upon the city of Plymouth. They also referred to Henry Moore's studies of people sleeping in the underground shelters during the blitz as documentary evidence of the effect of the war upon their daily lives.

Figures 4.30 to 4.36 are of work undertaken in Year 6 as part of a study of Tudor times where the teacher focused the children's attention upon Henry VIII and his wives through reference to the work of contemporary miniaturists. The children used this source material to recapture the appearance of King Henry in all his splendour and to show his six wives. A particular point was made of the use of the miniature painting as a bargaining counter between Henry and those diplomats from other countries who used the paintings to support the claims of foreign princesses to be future queens of England.

In all this work, there is no doubt that there has been a useful match between the requirements of the Programmes of Study in both Art and History to the benefit of both subjects.

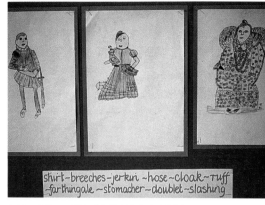

4.21 STUDIES OF TUDOR AND STUART COSTUMES
Year 4
Pencil and crayon

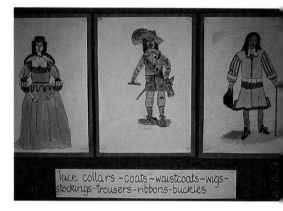

4.22 STUDIES OF TUDOR AND STUART COSTUMES
Year 4
Pencil and crayon

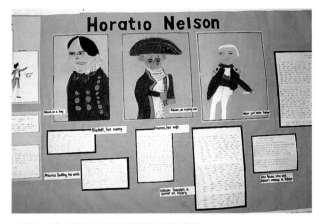

4.23 CLASSROOM DISPLAY OF WORK FROM A HISTORY TOPIC
Year 4
Work from class topics on voyagers and discoverers.

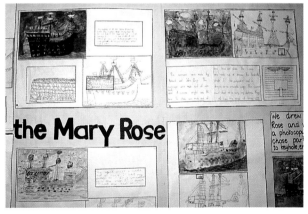

4.24 CLASSROOM DISPLAY OF WORK FROM A HISTORY TOPIC
Year 4
Work from class topics on voyagers and discoverers.

4.25 STUDY FROM 'LAST OF ENGLAND'
Year 5

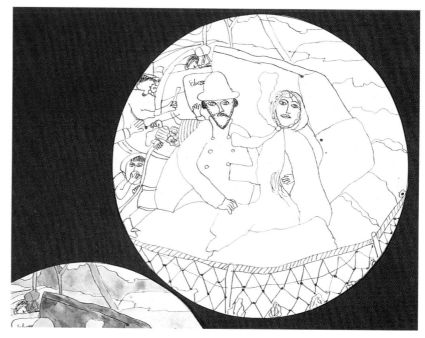

4.26 STUDY FROM 'LAST OF ENGLAND'
Year 5
Micro liner

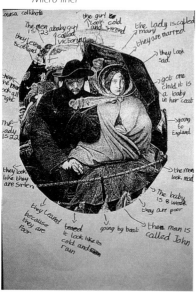

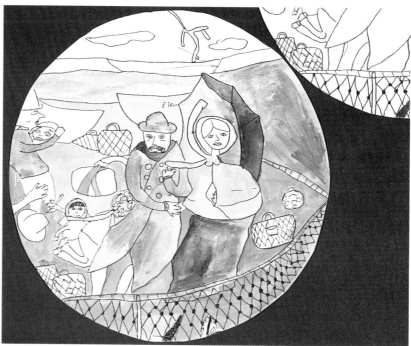

4.27 STUDY FROM 'LAST OF ENGLAND'
Year 5
Watercolour

4.28 THE BLITZ
Year 4
Tempera

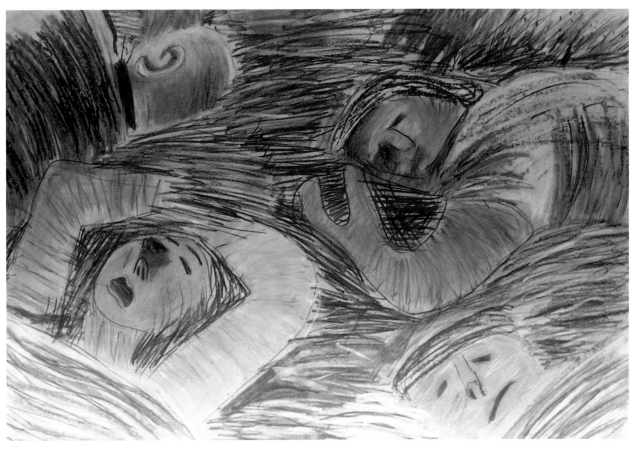

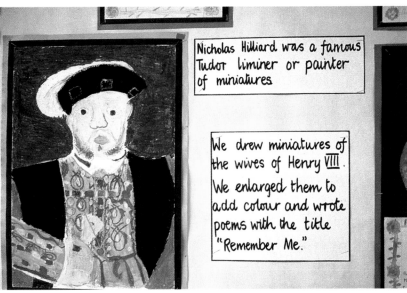

4.29 THE AIR-RAID SHELTER
Year 4
Pencil
Based upon Henry Moore's studies
of people sheltering underground.

Nicholas Hilliard was a famous Tudor liminer or painter of miniatures

We drew miniatures of the wives of Henry VIII. We enlarged them to add colour and wrote poems with the title "Remember Me."

4.31 HENRY VIII
Year 6
Mixed media

4.30 HENRY VIII AND HIS WIVES – CLASSROOM DISPLAY
Year 6

4.32 HENRY VIII
Year 6
Batik and embroidery collage

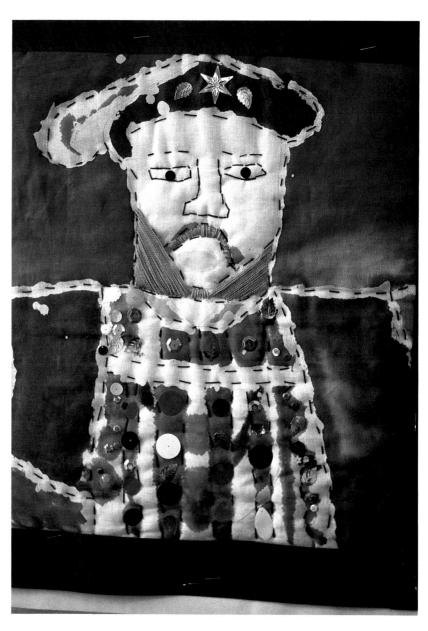

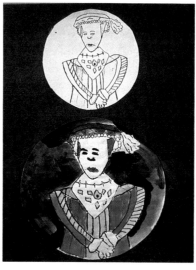

4.33 THE WIVES
Year 6
Micro liner and watercolour

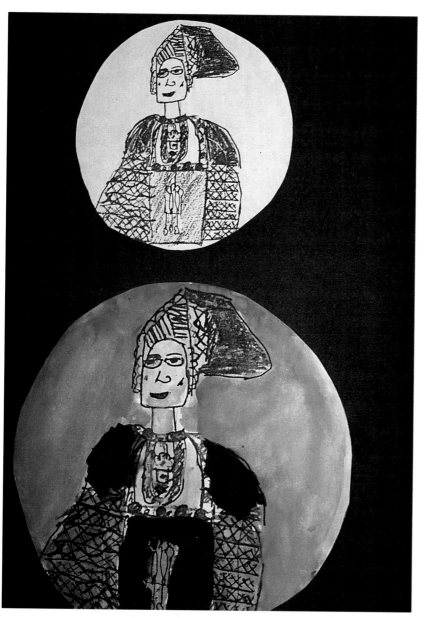

4.34 THE WIVES
Year 6
Micro liner and watercolour

4.35 THE WIVES
Year 6
Micro liner and watercolour

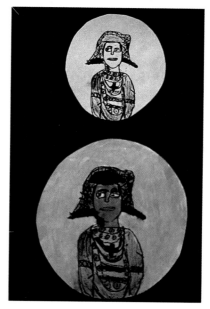

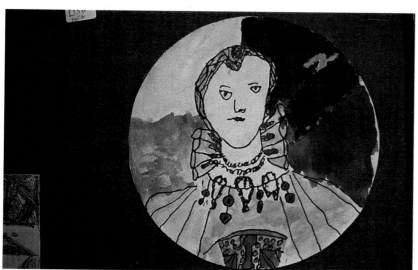

4.36 THE WIVES
Year 6
Micro liner and watercolour

Learning about the work of artists and designers

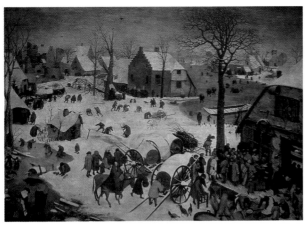

5.1 'THE CENSUS IN BETHLEHEM'
Pieter Bruegel, 1566
(Musées des Beaux-Arts, Brussels)
*Resources Pack no. 6

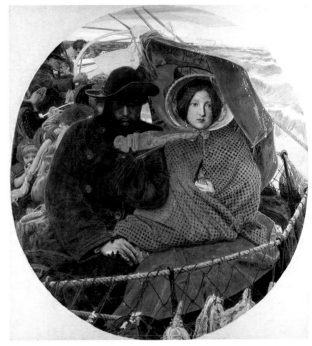

5.2 'LAST OF ENGLAND'
Ford Maddox Brown, 1852–55
(Birmingham City Museum and Art Gallery)
*Resources Pack no. 15

LEARNING ABOUT ARTISTS AND DESIGNERS

The National Curriculum in Art requires that children should become familiar with the work of artists, craftworkers and designers working at different times and in different cultures. They should be helped to appreciate and understand the important part that artists have played in the development and history of our civilisations.

In previous chapters there was a particular emphasis upon illustrating the different ways you might use the work of artists and designers to support and enrich the children's own making of images and artefacts, both within the Art curriculum and in relation to the teaching of other subjects. In learning about how artists make work, in becoming more knowledgeable about other artists' methods and systems, children come to have a better understanding of the possibilities of making within their own grasp. In studying the various ways that other artists have dealt with familiar subject matter in the natural and made world, children will learn much about how they themselves can make images and artefacts.

One of the simplest and most telling descriptions of Art and its development came from the painter Georges Braque who once said that 'All art springs from nature and from art'. Artists and designers are taught by artists and designers in much the same way that engineers are trained by engineers. All artists are influenced by their teachers and mentors and by the times and circumstances in which they live. The history of Art and Design is a study of the influences of one artist upon another and of the way that artists have used, built upon, and reacted against and rejected other artists' ideas and systems.

Georges Braque is, in effect, saying that although all artists draw upon their experiences of the natural and made world and their encounters within it, their view of the world is inevitably filtered through their knowledge about the work of other artists and the work they have made. In order for children to fully understand the work of artists they need to know something about the context within which their work was made, in addition to being familiar with their work. In the Teacher's Guide to the Resources Pack each work is accompanied by a statement about the work and about the artist who made it, in an attempt to give you sufficient information to know something about the work beyond its appearance. When you are using works of art with children it is important that you should seek out such information so as to help the children know something about the artist – what were the influences upon the work of that artist or designer and in what circumstances or for what purpose the work was made.

It is supportive to children's understanding of work to know, for example, that in 'The Census in Bethlehem' (figure 5.1) Pieter Bruegel was breaking new ground in representing events in the life of Christ as though they were happening to ordinary people in the 16th century; that Ford Maddox Brown's painting 'Last of England' (figure 5.2) was based upon his own experience of saying farewell to friends who were emigrating to Australia; that Abu'l Hasan's work (figure 5.3) was made to

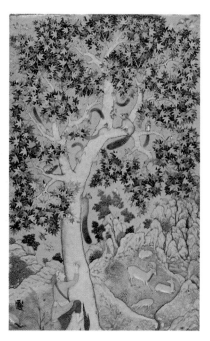

5.3 'SQUIRRELS IN A CHENNAR TREE'
Abu"l Hassan, circa 1610
(The British Museum)
*Resources Pack no. 5

decorate the buildings built to celebrate the political power and wealth of the Mughal Empire in India; that Henry VIII's choice of wives was influenced by the way they were represented by the miniaturists of the time.

Some work is so familiar and acceptable to us today – for example, the work of the Impressionist painters – that it is easy to forget that when it was made it created argument and controversy and was condemned by the critics of the time as being ugly and distorted. Today, we view the work of the Impressionists in different context to when it was made in the 19th century. Similarly, we may have difficulty in reading some contemporary work because we are not familiar with its context. Mondrian's painting 'Broadway Boogie-Woogie' (figure 5.4) may not begin to make much more sense to children than its geometrical pattern until you can help them 'read' it more effectively by relating it to its visual inspiration in the street patterns and lighting of New York city.

Although some contemporary work and some work from other cultures may be unfamiliar and appear difficult to understand at first sight, it is rewarding to pursue its meaning by seeking out the context within which it was made, its purpose and the ideas or source material that generated its appearance. Figures 5.5 to 5.7 illustrate the way that a teacher encouraged the children in her class to explore the ideas that generated the making of a sculpture by Richard Deacon. This sculpture had been placed recently in the locality of the school. By exploring the work the children were better able to understand Deacon's work.

Even when using familiar work such as that of the painter Vincent Van Gogh, it is useful to know sufficient about the artist's life and the influences upon his work to be able to help the children understand better how he came to paint in that vigorous and dynamic way. It is comparatively easy to trace the development of Van Gogh's way of painting through looking at the paintings of peasants by Jean-François Millet, the work of the Impressionists, paintings by Paul Gauguin and works by Japanese printmakers. In his letters to his brother Theo, Van Gogh also provides us with a vivid account of his own life and struggle to be a painter.

In helping children to place the work of artists and designers in context, you will be making them more aware of the reality of being an artist. They will come to know and understand that a painting or carving or mask is more than just an interesting image in a book or on a postcard. They are real images and artefacts made for particular purposes. Although you will necessarily have to rely a great deal on using reproductions and photographs of artist's work to make them accessible to children, you should also seek other ways to help them to appreciate the reality of being an artist or designer. You can do this by giving them occasional opportunities to see and handle original images and artefacts, by taking them to visit museums, galleries and craft workshops and by arranging for artists, craftworkers and designers to visit your school to talk to the children about their work.

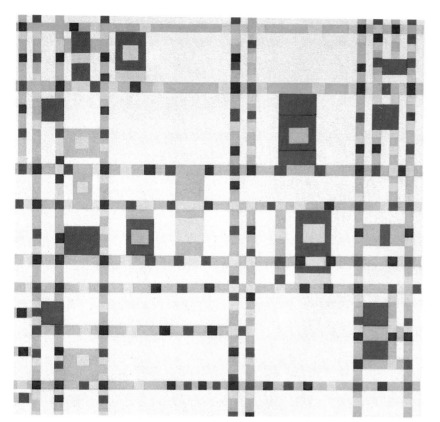

5.4 'BROADWAY BOOGIE-WOOGIE'
Piet Mondrian, 1942–43
(Museum of Modern Art, New York)
*Resources Pack no. 24

5.5 SCULPTURE AT THE RAILWAY ARCHES, PLYMOUTH
This work is based upon Richard Deacon's recollections of a railway journey through Plymouth.

5.6 STUDY OF RAILWAY SYSTEMS
Year 6
Pencil
Made to help the children understand the possible sources for Richard Deacon's sculpture.

5.7 STUDY OF RAILWAY SYSTEMS
Year 6
Pencil

RESOURCING WORK IN CRITICAL STUDIES

In order to develop a good programme of work in critical studies in your school you will need to collect and organise a good range of evidence about the work of artists and designers. This should include some good reference materials, such as one or two general art dictionaries for you and your colleagues to use; in addition to good collections of books, reproductions, postcards and photographs of the work of artists and designers to use in your work with children. You will also need to become familiar with the range of resources available in your locality, where buildings and artefacts will provide interesting evidence of the way that craftworkers and designers have helped to shape the community and where there are interesting collections in local museums, galleries and libraries. You may also have access to artists, craftworkers or designers who live and work in your own local community.

Reference material

The main source for your day-to-day work with children in critical studies will be through publications about the work of artists and designers and through the use of reproductions of artists' work, ranging from good quality prints through to postcards and other illustrations of work from various sources. For your own use you will need a good art dictionary and a collection of books dealing with the work of individual artists and the various movements or 'schools' of art. There are also on the market books about artists written specifically for children to read, where the text is more accessible than in the standard works on the lives of artists. It will take time to build up an appropriate collection which will provide you and your colleagues with evidence of the work of a cross-section of artists, craftworkers and designers. You will find it useful to use those retailers who market publishers' 'bargains' and 'remainders'. These can be found in most towns. You can obtain books about most of the popular and familiar artists and movements at reasonable prices.

You will also find that you can borrow collections of books about particular artists and designers from most local authority library services. The bibliography to the Teacher's Guide to the Resources Pack provides a useful starting point or 'shopping list'.

Illustrations

You will need a good collection of reproductions of the work of artists and designers for use in the classroom. These should include good quality, poster-sized reproductions, postcards and photographs. Large reproductions, like those in the Resources Pack, are essential for work based on class discussion and where you want children to make detailed studies of aspects of the work. An ideal combination is to have a good sized poster of the work which all the children can see and matching postcards for them to refer to and to use individually or in pairs. You will find collections of posters and postcards in your local galleries and museums and in art and craft shops. There are some companies that

specialise in providing packs of postcards of artists' work, with each pack containing 20–25 works by different artists on a particular theme; for example, the seaside, flowers and gardens, portraits etc. These are very useful for group discussion and comparison of different kinds of work. Many bookshops sell postcard books which include several works from one artist and calendars with good reproductions of artists' work. Other useful sources include the 'bargain' bookshops where you can buy economically a book about one artist and use the plates to make a collection of illustrations of his or her work. Also the Sunday colour supplements frequently feature well-illustrated articles about the work of different artists and designers.

Appendix 1 lists the London Galleries and Museums which publish books, posters and postcards about the work of the artists and designers featured in their collections.

Objects and artefacts

It will obviously be useful for you and your colleagues to begin to make collections of interesting objects and artefacts which have been designed and made by craftworkers or designed by designers and commercially produced in industry. It is valuable for the children to be able to make drawings and studies from real objects and artefacts made in different times and places. It is also useful for them to compare and contrast, for example, the appearance of a teapot made at the turn of the century with one made today, or the differences between toys made in different times and cultures. The study of such collections of artefacts will also be supportive to cross-curricular work between Art and Design, Technology and History.

In addition, you will find many interesting examples of artefacts and designed forms in your local community environment and in local museums and collections. The study of the built environment and of artefacts in everyday use helps children to understand how the appearance of our environment and of the things we use have been shaped and influenced by the work of artists and designers over the years. Appendix 2 lists examples of designed forms that can be collected or observed in the local environment.

Original works of art, craft and design

In addition to using familiar and everyday objects and artefacts for study and to learn more about the way that these are designed and made it is very important to find as many occasions as possible to give children experience of seeing and handling and studying original works of Art and Design. However well they are reproduced, photographs of paintings can only tell us so much about a painting. A postcard of a painting gives little indication of its real size and little information about the way that the pigment is used and applied. It is even more difficult to fully understand from the study of a photograph how such three-dimensional forms as ceramics, sculpture and carvings are made. They need to be experi-

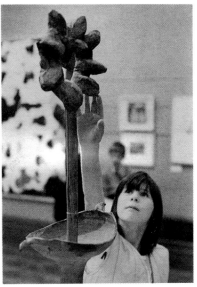

5.8 VISITING AN EXHIBITION
First-hand and tactile experience of the work of a contemporary sculpture at a local museum. (Photograph by Reg Stokes)

enced three dimensionally in the round, and often to be handled to fully understand their tactile qualities. (Figure 5.8 graphically illustrates the value to children of being able to handle a piece of sculpture and to appreciate its scale and quality.)

Although there will be significant variations from locality to locality, there are always opportunities for children to see original work, wherever your school is based. If you work in a city school, there will be local art galleries and museums where children can see original work. Many local commercial galleries and craft shops are willing to lend work to schools, as are those retailers that specialise in the work of designer craftworkers in such areas as fabrics, weaving and jewellery.

You can also seek to borrow work from artists and designers in your area. There are artists and designers working in most communities. The Art teachers in your local secondary school will almost certainly be professionally trained artists and designers and there are few communities that do not have a local artists' group or society. You may well have colleagues, parents or friends who practise one of the arts or crafts and who would be willing to lend original work or, better still, visit your school to talk about their work and how they make it.

It is of particular value for children to have the opportuntity to see an artist at work and to hear them talk about the way they approach making a painting, a pot or a weaving and to realise that artists work in much the same way as they do and experience similar problems and triumphs.

Aesthetic maps
It can be a useful exercise for you and your colleagues, or for a group of schools in one locality, to work together to make an 'aesthetic' reference map of your local community. This can provide information built up over time about where to find interesting examples and evidence of all kinds of art and design practice in your area.

5.9 WORKING WITH AN ARTIST
Mary Beresford-Williams, painter and printmaker, working alongside children as part of artist in schools residency.
(Photograph by Reg Stokes)

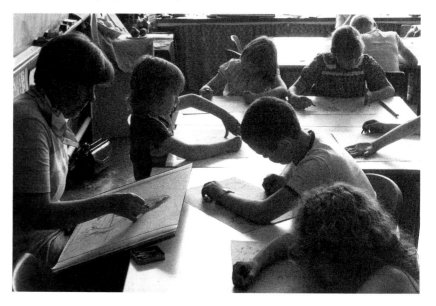

USING COLLECTIONS, GALLERIES AND MUSEUMS

In order to give children the opportunity to see as much original work as possible, you will need to make use of local collections of the work of artists and designers and become familiar with the range of work that is available for study in your locality. Some Local Education Authorities have loan collections of original works that you can borrow for exhibition in your school. Where you are fortunate enough to have access to loan collections you will need to become familiar with what is available through the scheme, so that you can forward plan the use of original work in association with particular projects or class themes. Most loan collections are arranged in small exhibition groups. You can borrow a group of work which may be a collection of paintings by different artists on a particular theme, e.g. of portraits or landscape, or of a group of work by a potter or weaver, or a collection of lino-cuts by different printmakers (figures 5.10 to 5.14).

5.10 STUDY FROM CERAMICS
Year 4
Pencil
Made from ceramic figures by Jennie Hale, from the touring exhibition to schools – 'Fabric and Clay'.

5.12 STUDY FROM CERAMICS
Year 4
Pencil

5.11 STUDY FROM CERAMICS
Year 4
Pencil

5.13 LANDSCAPE STUDY
Year 6
Tempera

**5.15 STUDY FROM PAINTINGS
BY BERYL COOK**
Year 5
Pencil and tempera

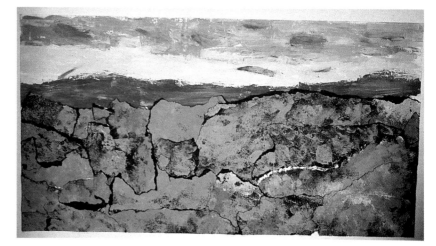

5.14 LANDSCAPE STUDY
Year 6
Tempera

Looking at the work of a local artist

You may also find that you have access to other collections in your own community. You may be able to borrow for exhibition in the school work from a local gallery or art centre, from a collector or from an artist or designer working in the area. Where you can, it is particularly appropriate to seek to borrow and use the work of local artists as such work has an immediacy to the children, especially where the artist's

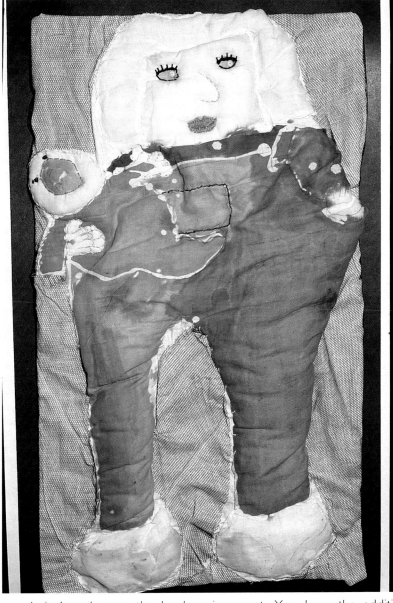

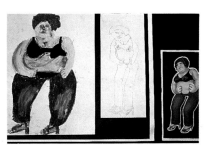

5.16 STUDY FROM PAINTINGS BY BERYL COOK
Year 5
Pencil and tempera

5.17 RECONSTRUCTION OF A CHARACTER IN A BERYL COOK PAINTING
Year 5
Batik

work is based upon the local environment. You have the additional possibility of being able to persuade the artist to visit your school to talk to the children about the work. Figures 5.15 to 5.18 show work by children based upon the study of the work of an artist living in the locality whose work is concerned with recording life and events within the community. The children studied the work of Beryl Cook in her home town of Plymouth.

Visiting galleries and museums

If you work in a city school or in a school in any of the larger towns, you will have access to collections of original work in the local museums, art galleries and arts centres. Many smaller communities are within reasonable travelling distance of these collections. Valuable collections of work are also to be found in many of the National Trust properties.

Most galleries and museums have permanent collections of work on

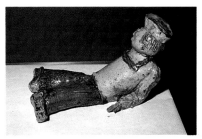

5.18 RECONSTRUCTION OF A CHARACTER IN A BERYL COOK PAINTING
Year 5
Ceramic

display in some of their rooms. In addition, some house touring and temporary exhibitions of the work of artists and designers. Arts centres will generally only house touring and temporary exhibitions. If you wish to use these collections, you will need to become familiar with what is available in the permanent collection and what touring exhibitions are planned. To do this, you will need to make sure that your school is on the museum or gallery mailing list and receives regular information about the current exhibition programmes. Many art galleries, museums and arts centres have education or liaison officers who will be pleased to consult with you about visits to exhibitions. They will support you in preparing for such visits and in planning practical activities for the children in association with exhibition visits.

Where your local museum or art gallery has a good permanent collection it will be useful for you to collect any books, posters, slides or postcards about work in the collection that you would particularly like to use with the children in your school. You can use these as the basis for discussion and study of the work before your visit. For many children, their first visit to a museum or art gallery may be both exciting and confusing simply because there is so much to see. You will therefore need to find ways to focus their attention upon works within the collection that it would be particularly helpful for them to study. A nice example of this is where the teacher gave each child in the class a postcard of one of the works in the local art gallery which they wrote about and made studies from before their visit. Their first task on arriving at the gallery was to find 'their painting' and then to make notes and write about the difference between the original work and its post-card reproduction.

You will certainly find it useful to focus the children's 'looking' at an exhibition or collection by using worksheets and questionnaires that require them to concentrate their study on particular works within the gallery. Where galleries and museums have education officers they will often have worksheets available that they have designed for use by children of different ages. These help them to explore particular works or themes within the collection.

When designing worksheets or questionnaires you will need to think carefully about which works to choose for study and how to use them to encourage children to seek out information within the work about how it was made and for what purpose. You will also need to consider how much realistically they can achieve within the duration of the visit and what kind of follow-up work might develop in school subsequent to the visit to the exhibition. Appendix 3 provides examples of worksheets used by teachers in association with a visit to a touring exhibition of paintings by L S Lowry in a local gallery.

Some art galleries and museums now have education or 'work' rooms which you can use for practical work with the children related to the exhibition. The education officers will often arrange for back-up displays of resources related to the work.

When children visit museums and galleries you will need to be sensitive to the fact that study of the work has to take place within the exhibitions themselves. You will need to provide the children with drawing and recording materials that can be used easily in these circumstances – for example, where it is essential that they use colour to record from some works they will need a selection of such 'dry' colour materials as oil pastels and coloured pencils in addition to the standard clipboard, papers and pencils.

Although taking children on visits to galleries and museums entails time and trouble in its preparation and planning, it is a very rewarding event for the children. It provides them with such rich opportunities to see original work and to appreciate, perhaps for the first time, the scale and dynamism and sheer presence of some works of Art and Design which cannot be experienced through any other means.

ARTISTS IN SCHOOLS

The most immediate way for children to learn about artists and designers is for them to see them at work and to hear them talking about their work. More than anything else, the artist's presence in school will help the children to appreciate the reality of being an artist or designer and to recognise that making a drawing, print or tapestry is real work depending as much upon perseverance and graft as upon inspiration or 'talent'.

You can, of course, give children some understanding of the artist and designer at work through using some of the many good films that are available on video. Characteristically these show the artist working at and talking about a particular body of work and illustrate how the artist's ideas are generated and developed through the making of the work. Although these are valuable, they are no substitute for the real experience of the artist's presence.

You can use artists in schools in many different ways and at different levels, ranging from an afternoon visit by a local artist or craftworker friend of the school to show their work and talk about it to the children, to a full-time residency by a professional artist or designer that may occupy several days. First of all, you will need to identify what artists, craftworkers and designers are working in your community and who might be available and willing to visit your school. You may have in the membership of your own school community of teachers, friends and parents, people who have trained in one of the Art and Design disciplines and whose experience might be called upon. These may be as various as a local potter or book illustrator, people who have trained as artists and still practise though now working in different fields, a retired person who has the time and motivation to pursue their work at a high level, or people working in local craft-based industries. Many such members of the local community may be happy to visit schools and to contribute time and experience free of charge as part of their own

commitment to good community relations.

It will obviously be sensible to try to arrange for such visits, talks and demonstrations to take place at times that are supportive to current work and projects in your school: for example, if you are planning a day's visit to a local site of interest, it would be supportive for the children to see the work of a local artist who has worked from the same site before their visit and to hear they have used the same experience.

You would find it useful to consult with members of the Art and Design Departments of those secondary schools your children progress to – some of whom will almost certainly be practising artists. They should have an interest in working with children in your school as part of their contribution to programmes of primary–secondary school liaison and continuity in your area. The National Curriculum does call for closer liaison between teachers working with children in Key Stages 2 and 3. It would be a useful beginning to root it in the use of that specialist expertise your secondary school colleagues might bring to the children in your school through their professional training as artists and designers.

Where you work in an urban school, you may have the additional advantage of access to a community of artists and designers through the School or Faculty of Art and Design based in your local Colleges of Further or Higher Education. Here there will be practising artists and designers, training artists and designers and opportunities of access to people working in different areas of Art and Design. Teachers and

5.19 LANDSCAPE STUDY
Year 6
Oil pastel

lecturers in Art and Design are sometimes willing to visit schools to talk about their own work and through their work will have detailed knowledge about other artists and designers working in the area.

5.20 LANDSCAPE STUDY
Year 6
Oil pastel

Figures 5.19 and 5.20 are of landscape paintings made by children in Year 6 following a visit to their school of a professional painter and printmaker teaching in the local College of Art. The children were inspired by his talk to make their own work based upon observation of the local landscape that he used as source material for his paintings and prints.

Artists in residence

Some Colleges and Faculties of Art use local schools to give Art and Design students opportunities for work experience in the community. It is worth exploring whether such schemes are available in your area. There are also a number of postgraduate courses where students training to be teachers of Art and Design are encouraged to undertake residencies in local primary schools as part of their own preparation to be teachers. Such schemes as these have been successful, in various parts of the country, in providing primary schools with artists and designers in residence at minimal cost.

Figures 5.21 to 5.24 show details from a mosaic wall made for a primary school by a group of students working under the direction of a mosaic designer teaching at the local College of Art. The children were involved in helping to design the mosaic and undertook their own mosaic

5.21 DETAIL FROM A MOSAIC WALL

Made by Elaine Goodwin and a group of students in residence at a local school.

5.22 DETAIL FROM A MOSAIC WALL

Made by Elaine Goodwin and a group of students in residence at a local school.

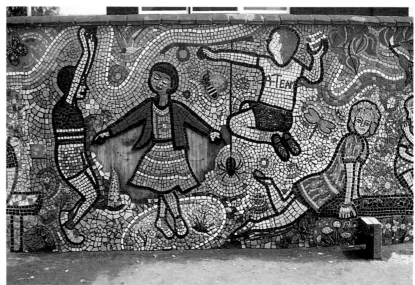

5.23 DETAIL FROM A MOSAIC WALL

Made by Elaine Goodwin and a group of students in residence at a local school.

projects in parallel with the project taking place in their own school.

Where you wish to use professional artists and designers to undertake residencies in your own school, you will have to explore the various funding options available to you in your own area. The average cost of a residency by a professional artist is about £100 per day. Many professional artists enjoy the opportunity to undertake such residencies and have experience and expertise in working with children in schools. In planning for such events you will need to consult with the Visual Arts officer of your Regional Arts Association and with the Adviser for Art and Design with your own Local Education Authority.

Many Regional Arts Associations publish directories of professional artists who are available locally to work with schools. Your local Adviser will have knowledge of those artists in the area who have had successful experience of working with schools. They will also be able to advise you about supporting funding for school residencies which are available through a number of agencies and which will often match any funding put into residencies by the schools themselves.

Although such residencies are expensive, they are a good investment in terms of the return they bring to the school and to the children in generating excitement and enthusiasm for the visual arts – just as residencies by writers and musicians and visits by theatre groups generate interest in the other arts. Many schools use professional artists in residence in association with special arts weeks or festivals sponsored by the school and where there is a conscious attempt by the school to act as the focus for celebrating the arts within the local community.

Because having a professional artist in residence is a significant investment, it is important to give considerable time and trouble to forward planning the residency and to ensure that maximum benefit flows from the experience and the expense. There are special occasions in the working life of schools when a residency may support and encourage both existing work and new developments, when they may be used to reinforce existing practice or to generate or celebrate new initiatives.

When you have established funding for a residency through your own school's budget, through local sponsorhip or through consultation with your Regional Arts Officer or Local Authority Adviser, you will need to consider which of the artists or designers available in your area are most suitable to meet the needs of your school. The artist will need to make a preliminary visit to discuss with you and your colleagues the best arrangements for the residency and how it will operate. It is important to remember that the main benefit of having an artist in residence is for the children to have the opportunity to see an artist at work and to share with them the ideas and processes that generate their work. Although most artists and designers are happy to be involved in stimulating work with children, they should not simply be used as substitutes for teachers. Ideally, a residency should provide equally balanced opportunities for the artist to pursue their own work, to share their work with children through talking to them about its progress and to provide teaching support through their own expertise.

A weaver in residence

There have been countless examples of effective residencies by artists of all persuasions in primary schools and where teachers and artists have worked well together to provide enriching experiences for children. The examples illustrated here show how two different schools used residencies by weavers in different ways and equally successfully. They generated interesting work with the children and gave them a real understanding of the way that a craftswoman works.

Figures 5.25 to 5.31 illustrate the work made by children in Years 5 and 6 alongside the work of a local weaver, Pat Johns, who had been commissioned to make a tapestry pictorial map of the town in which the children lived. The weaver brought to their school the tapestry she had made, together with the drawings and studies she had used in planning for its design. The children made their own studies of details of the

5.25/ A WEAVER IN RESIDENCE

5.31 Work undertaken by children in Year 6 during a residency by the weaver Pat Johns who had recently completed an illustrated map of the town in tapestry form.
The children worked on their own version of an illustrated map based upon their own studies of the town.

5.25 Sorting the wools
5.26 Setting up the loom.
5.27 The tapestry in progress
5.28/
5.31 Details from the completed tapestry.

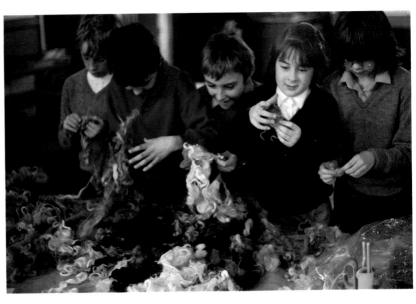

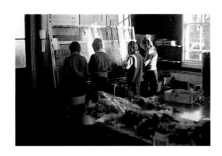

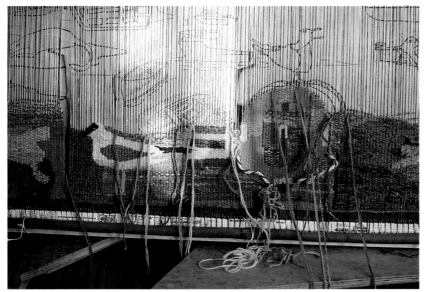

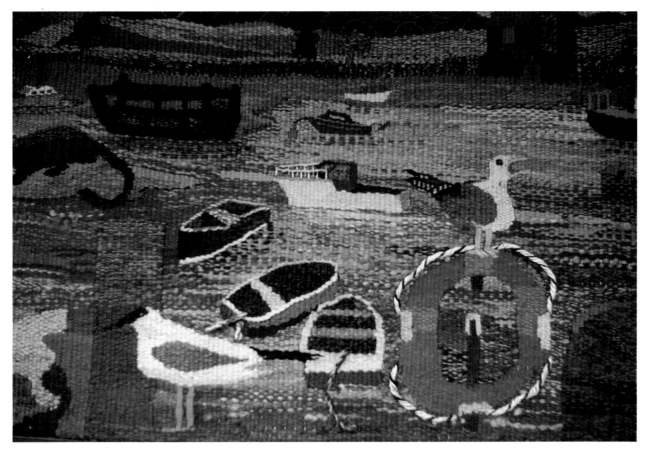

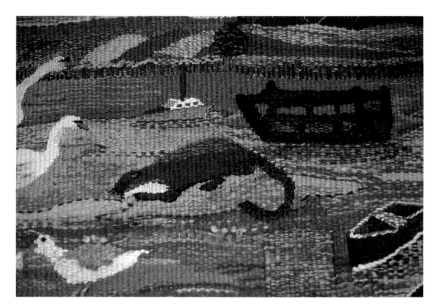

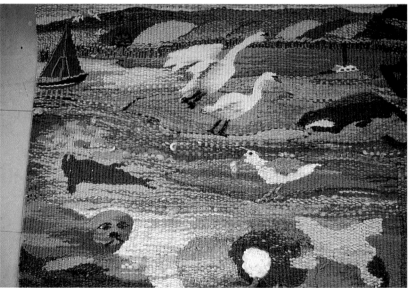

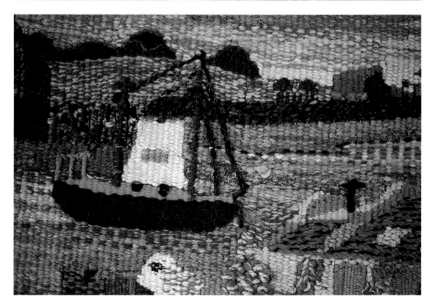

riverside town and with help and guidance from the weaver and their teachers planned and wove their own tapestry of the town. This project became the central activity in the school for a fortnight and the children were so motivated by this work they put in many hours of work in their own time to see the tapestry through to its conclusion and its hanging in pride of place in the local town hall.

Figures 5.32 to 5.37 illustrate the work made by children in Year 2 in association with the residency in their school of a weaver, Bobby Cox, who had just completed a series of woven tapestries based upon her visit to India. The designs were based upon the colours and shapes to be observed in India at different times of the day. The class teacher used the opportunity presented by this residency to initiate a cross-curricular project about everyday life in India. The children studied the way that people live and work in a typical Indian community and, like the weaver, made their own weavings based upon the study of the colours and shapes to be observed at different times of the day in their own locality. The work which flowed from this residency was shared with the local community through presentations about their work by the artist and the children to parents and to teachers and children in local schools.

In addition to the obvious benefits that such events bring to children's understanding of the work of artists and designers, many artists who have undertaken residencies have spoken enthusiastically about the value of such experiences to their own work. Many of them find it an exciting challenge to have to present their work and ideas to children and often to justify it to the curiosity and questioning that children confront them with.

In providing children with access to original works of Art and Design – through using collections, through borrowing work, through making visits to galleries and museums and by arranging for artists to visit your school to talk about their work – you will be giving them a real understanding of the way that artists work and knowledge about the images and artefacts they make. All of these activities will reinforce and extend their knowledge about the way that Art is made and will help them to place in context the study they make of the work of artists and designers from secondary sources.

5.32/ A WEAVER IN RESIDENCE

5.37 Work undertaken by children in Year 2 during a residency by the weaver, Bobby Cox whose exhibition 'An Indian Journey' was at the local museum and art gallery. This work was part of a cross curricular project about life on the Indian continent. Bobby Cox made weavings based upon the colours to be observed at different times of the day in India. The childrens weavings were based upon the study of the changing colours of the day in their own country.

5.32 Collection of resources about weaving
5.33 Pictures of different times of the day
5.34 Experimental weaving with coloured papers and based upon times of the day
5.35 First experiments in weaving with wools
5.36 Sorting the colours of sunrise
5.37 Sunrise weaving

We collected pictures of different times of the day.

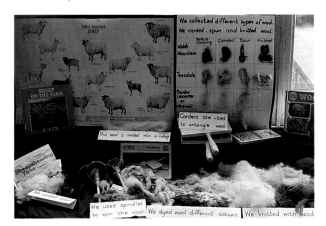

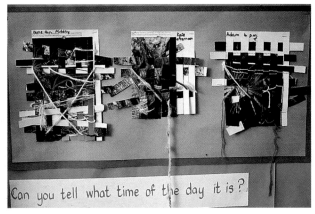
Can you tell what time of the day it is?

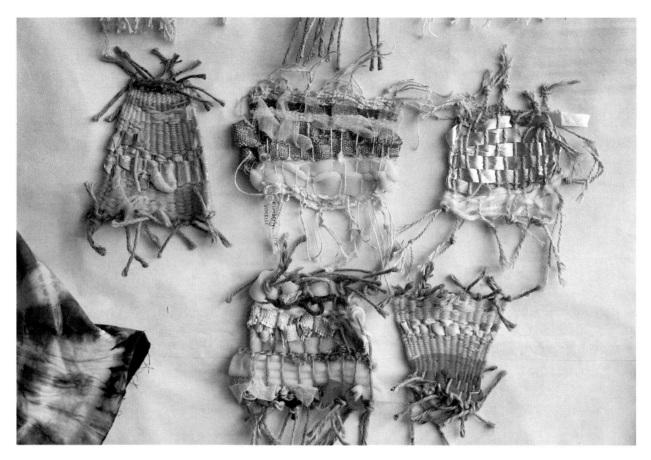

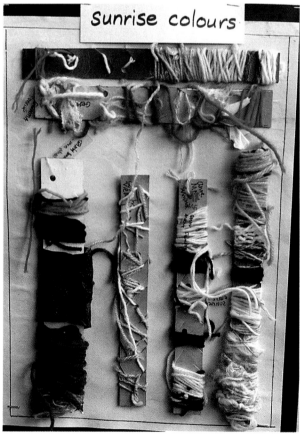

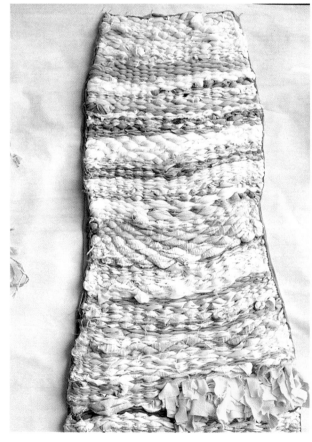

APPENDIX 1 LIST OF GALLERIES AND MUSEUMS WHICH PUBLISH RESOURCES

London collections

The Barbican Art Gallery, Silk Street, Barbican, EC2Y 8DS

Bethnal Green Museum of Childhood, Cambridge Heath Road, E2 9PA

The British Museum, Great Russell Street, WC1B 3DG

The Courtauld Institute, Woburn Square, WC1H 0AA

The Crafts Council, 44A Pentonville Road, N1 9BY

The Design Centre, 28 Haymarket, SW1Y 4SU

Hampton Court Palace, East Molesey, Surrey

The Horniman Museum, London Road, Forest Hill, SE23 3PQ

Imperial War Museum, Lambeth Road, SE1 6HZ

The Museum of Mankind, 6 Burlington Road, SE1 6HZ

The National Gallery, Trafalger Square, WC2N 5DN

The National Maritime Museum, Romney Road, Greenwich, SE10 9NF

The National Portrait Gallery, 2 St Martin's Place, WC2H OHE

The Natural History Museum, Cromwell Road, SW7 5BD

The Royal Academy of Arts, Picadilly, W1V ODS

The Saatchi Collection, 98A Boundary Road, NW8 ORH

The Serpentine Gallery, Kensington Gardens, W2 3XA

The Tate Gallery, Millbank, SW1P 4RG

The Victoria and Albert Museum, South Kensington, W1M 6BN

The Wallace Collection, Manchester Square, W1M 6BN

The Whitechapel Gallery, 80–82, Whitechapel High Street, E1 7QX

The William Morris Gallery, Forest Road, Walthamstow, E17 4PP

APPENDIX 2 OBJECTS AND ARTEFACTS

Examples of designed forms that can be collected or observed in the local environment and which can be studied to make comparisons between objects and artefacts designed and made at different times and in different places.

toys
dolls
games
playing cards
puzzles

sewing machines
typewriters
radios

kitchen utensils
knives, forks and spoons
kettles
teapots
cups and saucers
salt and pepper pots
can openers
corkscrews
nutcrackers

hand tools
garden tools

musical instruments

costume:
hats
shoes
gloves
belts
fans
jewellery
garments worn for
special occasions

illustrated story books
photographs
posters
graphic books
postage stamps
food cartons

street furniture:
lamps
railings
benches
litter bins
doors
windows
chimney pots
brick patterns
keyholes and letterboxes
door knockers
hinges and latches
house numbers
street signs
shop signs

memorials and monuments
gravestones
public statues

APPENDIX 3 WORKSHEETS

The following worksheets were used by teachers in association with a visit to a touring exhibition of paintings by L S Lowry in a local gallery.

A HARD DAY'S WORK

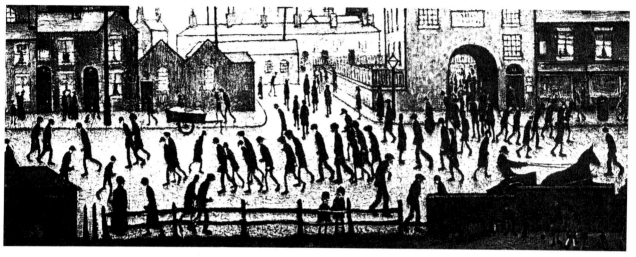

Coming from the Mill, 1930

In this painting you will find many people leaving a factory after a hard day's work.

On a separate piece of paper make careful drawings of at least four of these people leaving the factory. Try to show in these drawings how their tiredness shows as they leave work. Look carefully at the way they stand and the way they walk.

Follow up
Make studies of other groups of people in the City who are going about their work in various ways, or shopping or waiting for buses or just enjoying the scene.

Working with other children you might make a group painting or collage on one of these themes:

Busy in the City
Coming from the Football Match
Leaving Church

CELEBRATING

V E Day, 1945

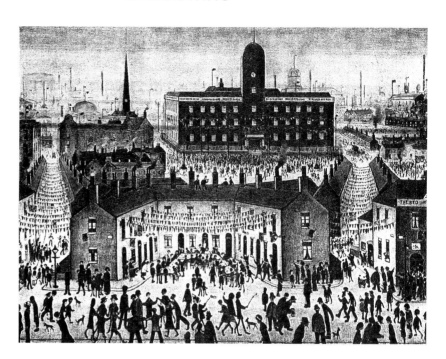

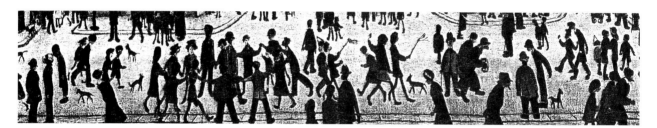

The crowd of people in this painting are celebrating a great occasion — the end of a war. How can you tell they are happy and enjoying themselves in different ways?

In the spaces below make three careful studies of individual people or groups of figures to show how happy they are to be celebrating in this way.

Follow up

Look at other paintings of people who are enjoying themselves at parties or dancing or at feasts.

You will find paintings by the following artists particularly helpful:

Pieter Bruegel
James Tissot
Auguste Renoir
Henri Toulouse-Lautrec
Edgar Degas

Compare the various ways that they create in their paintings a sense of fun and occasion. Make studies of different figures within their paintings and compare these with the figures in the painting by Lowry.

Do these studies help you to think about the way you might make a drawing or painting of occasions you enjoy?

A party
A disco
A Christmas Feast
etc.

PEOPLE IN SPACE

Good Friday, Daisy Nook 1946

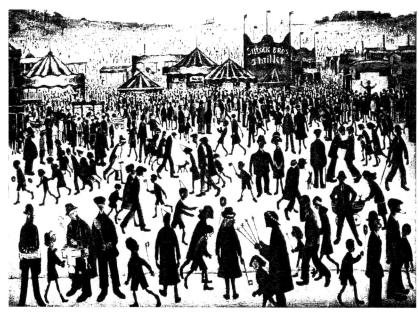

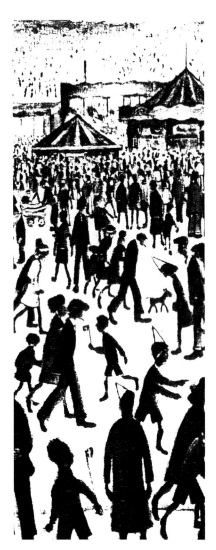

In his crowd scenes, the artist creates a very real sense of space by showing how figures both overlap and diminish in size when we see many people gathered together.

You can see this more clearly if you take a section through the painting as in the example on the left.

In the space provided on the right of this page make a careful study of the arrangement of figures in one section of the painting.

Follow up
Use different shaped view finders to observe and record sections of crowds of people in familiar environments – the local supermarket, the school playground, shopping in the city, etc.

Bibliography

Adams, E and Ward, C, *Art and the Built Environment* (Longman 1982)

Art Advisers Association, *Learning through Drawing* (AAA 1976)

Barrett, M, *Art Education: A Strategy for Course Design* (Heinemann 1980)

Clement, R T, *The Art Teacher's Handbook* (Hutchinson 1986)

Clement, R T (ed.), *A Framework for Art, Craft and Design in the Primary School* (Devon LEA 1990)

Clement, R T & Tarr, E, *A Year in the Art of a Primary School* (NSEAD 1992)

D E S, *The Curriculum from 5 to 16* (HMSO 1985)

D E S, *Art in Junior Education* (HMSO 1978)

D E S, *Art for Ages 5 to 14* (HMSO 1991)

Eisner, E W, *Educating Artistic Vision* (Macmillan 1972)

Gentle, K, *Children and Art Teaching* (Croom Helm 1985)

Gulbenkian Foundation, *The Arts in Schools: Principles, Practice and Provision* (Gulbenkian Foundation 1982)

Kellogg, R, *Analysing Children's Art* (National Press Books 1972)

Morgan, M, *Art 4-11* (Blackwell 1988)

N S E A D, *Art, Craft and Design in the Primary School* (NSEAD 1986)

Robertson, S, *Rosegarden and Labyrinth* (RKP 1963)

Robertson, S, *Creative Crafts in Education* (RKP 1963)

Schools Council, *Resources for Visual Education 7-13* (Schools Council 1978)

Taylor, R, *Educating for Art: Critical Response and Development* (Longman 1985)

Thistlewood, D (ed.), *Critical Studies in Art and Design Education* (Longman 1989)

Index